THE ART OF
GILLIAN JAGGER

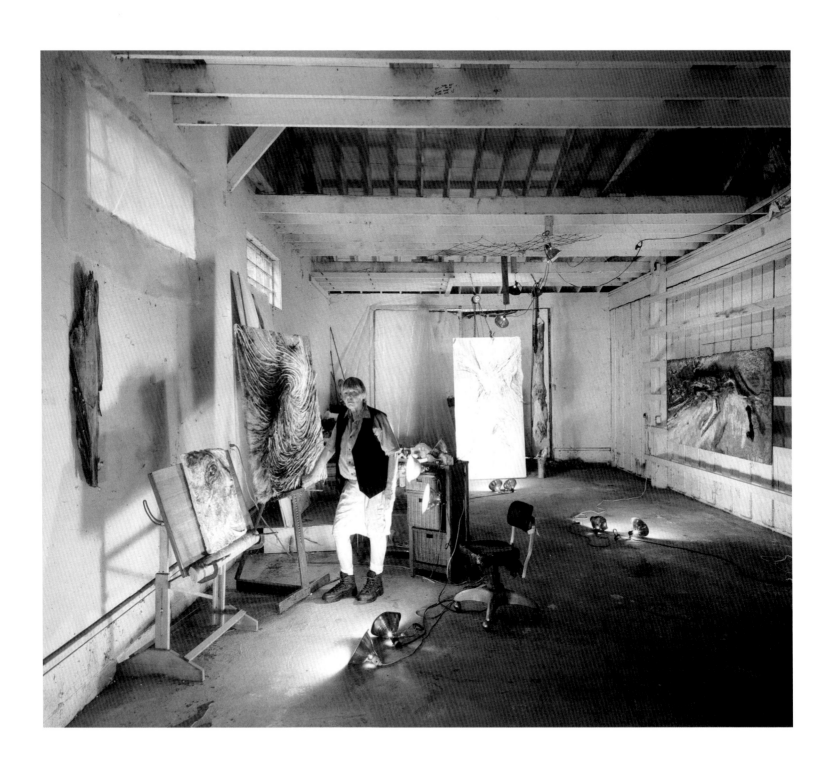

THE ART OF
GILLIAN JAGGER

WITH ESSAY BY MICHAEL BRENSON

ELVEHJEM MUSEUM OF ART

UNIVERSITY OF WISCONSIN–MADISON

2003

The book is published on the occasion of the exhibition *The Art of Gillian Jagger*, organized by Russell Panczenko and held at the Elvehjem Museum of Art, University of Wisconsin–Madison from November 23, 2002 through January 19, 2003.

Cover illustration: *Rift*, 1999, on exhibition in the Elvehjem Museum of Art, November 23, 2002–January 19, 2003. Photo by Russell Panczenko

Back cover illustration: *Spiral*, 1996–1999, on exhibition in the Elvehjem Museum of Art, November 23, 2002–January 19, 2003.
Photo by Jim Wildeman

Frontispiece: Gillian Jagger in her studio in Kerhonkson, New York, spring 2002. Photo by Russell Panczenko

Library of Congress Cataloging-in-Publication Data

Jagger, Gillian, 1930-
 The art of Gillian Jagger / with essay by Michael Brenson.
 p. cm.
"Exhibition held at the Elvehjem Museum of Art, University of Wisconsin-Madison from November 23, 2002 through January 19, 2003."
 ISBN 0-932900-97-6
 1. Jagger, Gillian, 1930---Themes, motives--Exhibitions. I. Brenson, Michael. II. Elvehjem Museum of Art. III. Title.
 N6537.J3237A4 2003
 730'.92--dc21
 2003009026

CONTENTS

FOREWORD

In the summer of 2001, on a visit to photograph Judy Pfaff's studio in Kingston, New York, I asked Judy about other artists in the area who might be amenable to my visit. She smiled and said, "Let me make a call; I have a great idea for you." One hour later we set off for Kerhonkson, about twenty miles away, where I met Gillian Jagger for the first time.

Jagger's home is an idyllic farm located at the foot of the Catskills. As one drives up to the house, an extensive vista opens to the right. To the left, nestled against the hillside, a green barn functions as her base studio. Entering the barn, I first found myself in a dark, large but intimate space. Incandescent floodlights, strategically placed on the rough wood floor, were the only source of light. They illuminated large sections of tree trunks and a number of massive gray shapes with heavily wrinkled, skin-like surfaces and filled the room with strong mysterious shadows. The atmosphere was magical and completely enveloping. Gillian, who had led the way, stood in the middle of the room, dramatically lighted from below like everything, hands in pockets, silently trying to read my response. I had entered into a private world, inhabited by her creations. This, in effect, permanent installation was the introduction, the forecourt, to the workspace beyond.

Gillian's studio area was also dark and intimate, a refuge from the world outside. Again, its only light source consisted of moveable floodlights scattered on the floor. It was here that I encountered *Absence of Faith (Faith I and Faith II)* for the first time. We sat and talked about the piece for some time.

Later, we went to a second, a much larger, barn on an adjacent property where the upper level was also a studio. Here, the atmosphere was quite different. Although there were no windows, the high arched roof was perforated by numerous openings where shingles and planks had fallen away. Streams of sunlight suffused the space with light. Hanging white sheets, which served as screens to divide the huge open space of the barn into distinct work areas, also reflected and diffused the incoming light in various directions. The areas defined by the hanging sheets contained Gillian's installations. In one was *Matrice*, in another *Spiral*, in yet another *Rift*. In addition, several large freestanding sculptures stood in the center of the space. Gillian moved from area to area talking passionately, explaining each of the works. It was a wonderfully memorable day.

I was immediately enthusiastic about bringing Gillian's work to the Elvehjem. The deeply felt environmental content and formal qualities of the work would certainly resonate with Madison audiences. Also, although some of her individual works had been exhibited in museums and discussed in newspaper reviews, group exhibition catalogues, and art journals, there had not been an overview presentation and/or publication of her work. Gillian's art certainly merited such consideration. It was clear from the beginning, however, that such an undertaking would not be without its challenges. The individual installations were large and extremely complex. Furthermore, there was a strong relationship between the different installations and the distinctive setting where they had been created. What would happen to them once they were removed from their original context? Fortunately, *Rift* and *Matrice* each had been shown at the Phyllis Kind Gallery in New York City and *Absence of Faith (Faith I and Faith II)* soon would be. Thus there was a roadmap.

We brought *Spiral*, which had never shown outside of the large barn where it had been created, to Madison in December of 2001. It was installed in the Elvehjem's Paige Court, as one in a series of year-long installations that the museum has been offering in that space over the past decade. For a museum with a small staff, the logistics were daunting. Shipping tree trunks half way across North America was the easy part. Hanging them from a forty-foot high ceiling was another matter. We will always be grateful to Jessica Perlitz and Jamie Hamilton for their invaluable assistance with this part of the project. Jess, former studio assistant to Judy Pfaff, had worked on an earlier installation in Paige Court by that artist and was therefore familiar with our building and our staff. Jamie, also a Pfaff assistant, who occasionally worked in Gillian's studio, also brought important mountain climbing skills without which the installation would have proved impossible. Mental images of him climbing from the thirty-foot Genie lift, the highest we could get, to and from a platform suspended five feet below the forty-foot ceiling to drop plumb lines and chains still inspire awe.

The Art of Gillian Jagger, which opened on November 23, 2002, brought thirty-two additional works to the Elvehjem, including the installations, *Rift*, *Matrice*, and *Absence of Faith (Faith I and Faith II)*. The entire exhibition was mounted in less than three weeks. Outside assistants again helped to solve the logistical challenges of the project. The University of Wisconsin–Madison's Physical Plant, under the capable leadership of Steve Grever, created an aesthetically and functionally suitable false ceiling in part of Brittingham Gallery VII, which had never been designed for contemporary installations, to which we could attach the heavy chains and dozens of wires necessary to hang *Rift*. Bill Curran, who several years earlier had helped Gillian transfer first *Matrice* and later *Rift* from her barn in Kerhonkson to the Phyllis Kind Gallery in New York City came from Philadelphia, while Jim Zellinger, who had similar experience with *Absence of Faith (Faith I and Faith II)* came from upstate New York. Jessica Perlitz again returned from Toronto to lend her expert assistance to both the installation and deinstallation of the exhibition.

The present catalogue, which documents the Elvehjem exhibition of Gillian's work, is greatly enhanced by the brilliant essay contributed by Michael Brenson. Although he was a longtime champion of her work, I was delighted when he agreed with me that it was preferable to write about Gillian's work after seeing the exhibition rather than before it was even mounted. The several days he spent in Madison and the countless hours with Gillian in New York resulted in a sensitive and profound insight into the artist's work. The Elvehjem is indeed proud to be able to include it in the present publication.

I want to thank Barbara Gordon and Richard Schlesinger for their excellent film *Casting Faith*, a one-hour documentary portrait of Gillian Jagger, which they graciously lent to the museum during the course of the exhibition. The film, subsequently much sought after by local educators, greatly enhanced the audience's experience and appreciation of the artist's work. James Steinbach and others at Wisconsin Public Television facilitated the completion of the film and its presentation on public television in the state.

I must acknowledge the Elvehjem staff 's commitment to every stage of this project from fundraising by development specialist Kathy Paul to management by assistant director for administration Carol Fisher. Installation of the massive yet delicate and complex

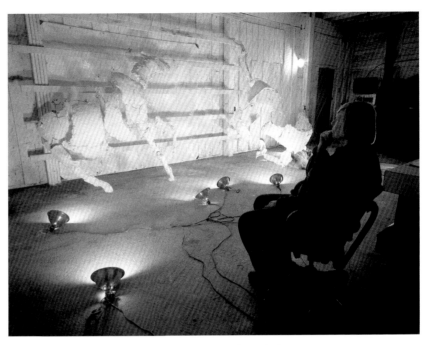

objects has been handled with even more than their usual aplomb by exhibition designer Jerl Richmond and preparator Steve Johanowicz and their prep crew. Curator for education Anne Lambert diligently planned educational programs. Former assistant registrar Jennifer Stofflet worked with the photographer and made travel arrangements, and editor Patricia Powell managed the catalogue production process. In addition to our immediate staff I want to thank Jim Wildeman for his excellent photography and Earl Madden of UW Communications for his sensitive design for the catalogue.

The Elvehjem exhibition and catalogue of Gillian's work were made possible by generous grants from Norman Bassett Foundation, Pleasant T. Rowland Foundation, and UW–Madison's Anonymous Fund. We are also grateful to Pratt Institute for their moral and financial support of Gillian Jagger, including a grant that made it possible for Gillian to give us so much of her valuable time.

Finally a personal note of thanks to Gillian Jagger herself: it was truly a pleasure and an honor to have the opportunity to get to know her and her work. Thank you.

Russell Panczenko
Director, Elvehjem Museum

7

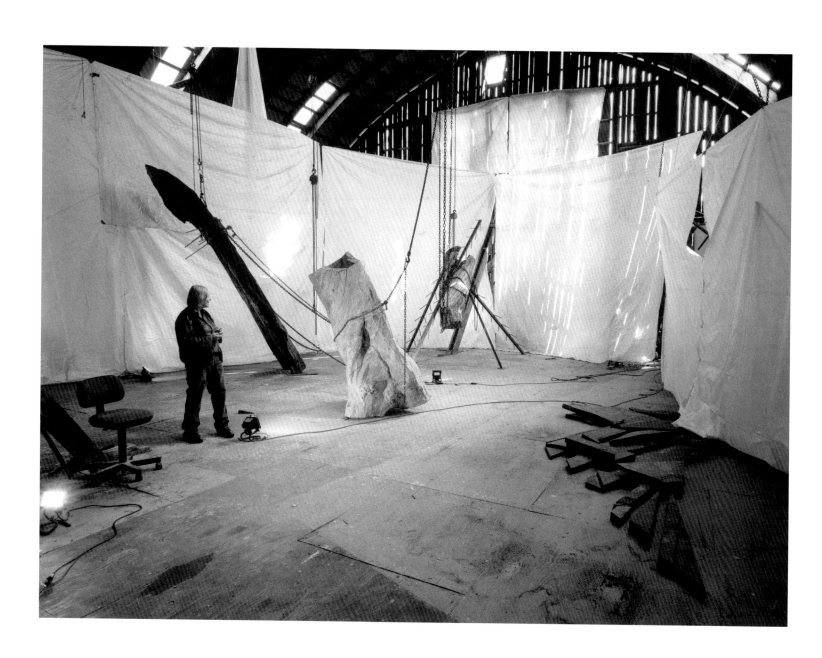

SHOCK OF THE
REAL

Michael Brenson

"I have had a life of shocks."

"I've always known that life's better than art somehow. That animal has more truth in it than whatever I can make of it."

"I remember Tennessee Williams said: You never talk to another person. We just each talk to that person between us. That's really a scary thought. I've made that person up, it's you. You've made that person up, it's me. And we're having that conversation. I would say in that teaching situation that there's no one between us. They make themselves vulnerable to me. I make myself vulnerable to them. Something transmits. And if art can be that strong, there's something worthwhile in that."[1]

Gillian Jagger was born in London in 1930. Her father, Charles Sergeant Jagger, was a war hero and a celebrated sculptor best known for his 1919–1920 *No Man's Land,* a funereal antiwar relief in the Tate Art Gallery, and his soberly monumental 1921–1925 *Royal Artillery Memorial* at London's Hyde Park Corner. Her mother, Evelyn Isabel Wade, was the daughter of Lillian M. Wade, a sculptor known for large bronzes, and the granddaughter of Roland Morris, another sculptor, whose commissions included terra cotta relief panels at the entrance of the Wedgewood Memorial Institute in northern England. In 1934, shortly after buying a farm in Southwald, 100 miles from London, on the west coast of England, C. S. Jagger, living with a bullet near his heart, caught a cold in London and died of pneumonia at forty-eight. He had not had time to modernize the thatched roof cottage and convert its five barns into his dream studio. The younger of his two daughters rode cart horses and looked after a number of animals, including her father's dog. On Paradise Farm, Jagger felt she was living in the warmth of her father's shadow. "He never came there, but I always felt his presence there," she said.

It was the place I was happiest. ... What made up for the loss of him was the richness of country living—the very thing my mother hated. It must have been terrible for her—no refrigerator, no toilets—but I loved the outhouse, bringing water, and having horses pull the hay, cutting the hay. I had a baby runt bull as a pet.

In 1939, Jagger's mother moved with her daughters to Buffalo, New York, where her new husband, John Quentin Clarke, who was born in Canada, ran the J. Q. Clarke Coal Company. Two years later, Jagger's older sister, Mary Evelyn ("Doonie"), died in Toronto of spinal meningitis. Her mother, who had brought Doonie into contact with the carrier of the disease, shifted the blame onto her surviving daughter, whose "wildness" and "incorrigibility," she said, obliged her to send her daughters to school in Toronto. It was there, her mother intimated, that Doonie had contracted the disease. When Jagger tried to console her after the death, her mother lashed out. "Why wasn't it you? Why is it that the good ones die? Why is it that the good ones are taken and the bad ones live?" "I never reached out for her again," Jagger said. "After losing my sister, I lost my voice for a year. I didn't speak." The distance from Europe increased her sense of isolation.

I was taken away when my country was going to war, and I didn't want to leave my country. Americans didn't seem to know anything about it and didn't seem to care about it, and we seemed miles away from the German war. ... I felt very different over that, and very involved in the feeling of England being bombed. I had a wonderful aunt who wrote me letters all the time. I felt like a traitor; like I left my country.

Her mother forced her to come out as a debutante, which Jagger "hated," and expected her to make a mark in the Buffalo society to which she was determined to belong. Jagger ran away with a boyfriend, returned, then went off to Pittsburgh's Carnegie Institute of Technology (now Carnegie Mellon University), a rigorous school that at the time pushed its students so hard that, according to Jagger, "people had breakdowns all over the place."[2] When she enrolled, she did not want to be an artist. "I've seen the little animals I made when I was four years old, when my father gave me clay, and I was too good at it. I did portraits at twelve that were of anybody and everybody, and the skills and abilities began to worry me. That's when I decided to be a writer."[3] An English teacher who knew her father's work and recognized her gift for words convinced her to be her father's biographer. In her freshman and sophomore years, she attempted suicide, was nearly raped by a friend's boyfriend and defied regulations that seemed to her unfairly constraining. "I would wear blue jeans and whatever, and I didn't care about the hours. The guys were working late in the studio, and I wanted to work late in the studio. So I just didn't pay any attention to their rules." At one of her most desperate moments, in Buffalo, between her sophomore and junior year, after not eating or leaving the house for ten days, Jagger found herself drawing profusely. "It was almost like an animal wanting to be active, with its hand or something."[4] After returning to college, she concentrated on art, and the painter Balcomb Greene (1904–1990), one of her teachers, became a mentor and friend. She graduated in 1953 as a painter.

Jagger settled in New York City during the heyday of Abstract Expressionism. While wary of any rhetoric that found inherent meaning in gesture and in the movement of paint, she was marked by defining aspects of the Abstract Expressionist action aesthetic, including its attention to process, its approach to artistic space as an expansive, participatory field, and its belief that art could not be transformative if the making and the experiencing of it did not include existential confrontation. A few years later, Jagger met Andy Warhol, who told her: "You're the real thing." She remains grateful for his encouragement and acknowledges the importance of Pop art's interest in everyday objects that had not been considered worthy of artistic attention. But she despised Pop's obsession with consumer culture. "I thought Pop Art was terrible. I don't care about the Grand Union," she said. "I don't like seeing a stack of soup cans. I hate seeing beer cans. I don't like the smell of popcorn" or a "big fat pie in a plastic dish."

The artistic decade to which Jagger feels she most belongs is the sixties, when virtually everything was thrown into question. "All metaphor had dropped dead for all of us at that time," she said.[5]

When Truman Capote stripped everything in *In Cold Blood* and threw away all the power of poetry, I respected it. Then, Edward Albee did the same thing with motherhood, motherhood instead of being a touching thing that made us all cry had become something that has no meaning because it's so overused—like "family values." Like something pressed into your mouth that you don't want and they shove it in.[6]

Figure 1. Gillian Jagger, *Cast Cat*, 1961.

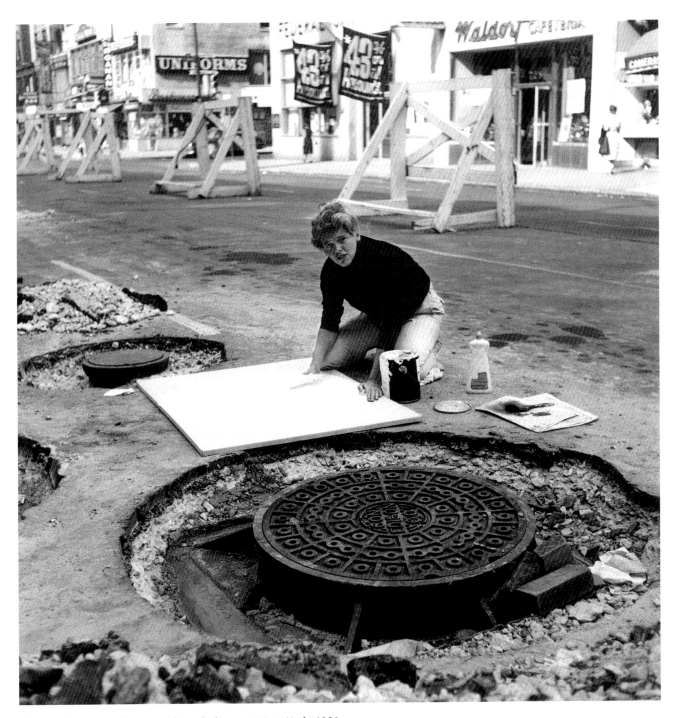

Figure 2. Jagger making cast of manhole cover, New York, 1964.

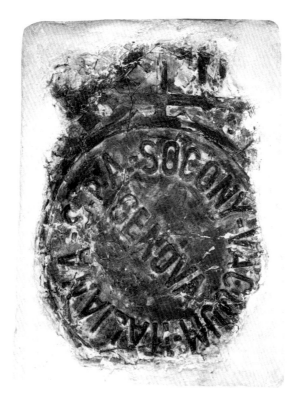

Figure 3. Gillian Jagger, *Genova* (cast manhole cover), 1965.

Figure 4. Gillian Jagger, *Track in Central Park*, 1966–1976, cast plaster and resin, 37 x 52 in.

During that decade her generation, she said, lost "belief in the material thing," lost "belief in content." "What can we do that's honest?" was one of the foundational questions she and many other artists, including those identified with Minimalism and Conceptual Art, asked. "Everyone had to start from scratch, but I was looking at a different scratch. I felt I was more emotional and psychological and I had to go off on my own."

Wanting her work "to speak as part of something already existing rather than as something I made up," she found herself drawn to sculpture.[7] She began making plaster molds of things not even George Segal had thought of casting into art, including a run over dog and a cat stoned to death by kids in front of her Upper West Side apartment building, by Central Park (see figure 1). Over the next few years, she also cast "parts of roads, tracks, footprints, manholes, and finally water, by adding cement to the downhill pour."[8] The first works to bring

her visibility were plaster casts and rubbings of manhole covers—circular steel lids with low relief patterns that suggested to her Assyrian reliefs and Egyptian hieroglyphs. Manhole covers are ubiquitous features of the urban landscape run over hundreds of times a day by cars and buses whose drivers are oblivious to them (see figures 2, 3, 4). The covers are also gateways to a vast subterranean shadow world whose labyrinthine intricacies and nomadic networks are largely excluded from the discourses of daily urban life.

The convulsiveness of the early and mid-sixties was followed in the late sixties and early seventies by widespread artistic interest in discovering and recovering viable and enduring connections. Feminist art, determined to shift the focus of art and society from the "I" to the "we," insisted on the importance of empathy and on basic affinities between the human body and the earth.[9] Although Jagger had already experimented with

nonart materials like tar and bridle dust, it is just as hard to imagine her subsequent sculptures and installations without the investigations of Earth artists like Robert Smithson, who helped redefine art by revealing the energy of materials like dirt and rust that were widely regarded as discountable waste. In his reveries on entropy, Smithson argued that human beings are always going backward as well as forward, and that ideologies of progress that do not take into account the truthfulness of disruption and decay are repressively idealistic. In his poetic realism, slickness and finish are lies. Smithson was far from the only artist interested in such mythical patterns as spirals.[10] Many others were fascinated by myths and rituals involving stones and trees and in imagining as art any aspect of the universe, including astral bodies like the North Star, or natural phenomena like lightening, as artistic materials. Nancy Graves, who became a friend of Jagger in the eighties, was one of several Post-Minimalists who made the study of anatomy and archaeology, and a belief in the magic of bones and fossils, part of the conceptual armature of their work. (See figure 5.)

In 1978, while continuing to maintain her apartment as a city base, Jagger and her partner, Consuelo Mander, bought a former farm with five barns in the rolling hills of Ulster County, 100 miles north of Manhattan. In the daily acts and rhythms of farmers, Jagger found a purposefulness she did not find in the city, with its "unnatural hurry, hurry, hurry—the corporation needs you in the morning."[11] For the last twenty-five years, her work has been shaped by daily walks with her dogs, tending and riding her horses, and studying both the tracks and habits of animals and people and the ebbs and flows of landscape growth and decay. She has made sculptures based on her body and on the bodies of horses and used sculptures to reveal links between the human body and the flesh and bone of the rest of nature. Her lead sculptures are like nervously animated shells and shelters that also suggest soft and crinkly fabrics in conversation (see figure 6). "I began working with sheets of lead that I hung up and let slump into natural bulges, which I then backed with resin."[12] The creased and rolling formations she made in these lead skins by

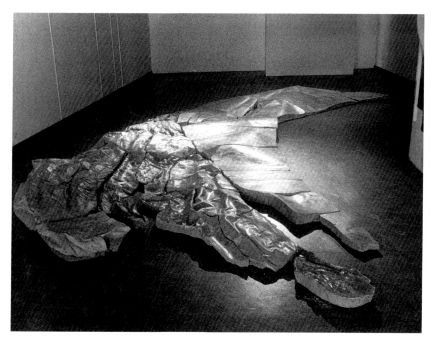

Figure 5. Gillian Jagger, *Comhla-Ri*, 1983–1986, polished cement, 3 x 30 x 16 ft.

"poking and pushing" with "the rubber toys you make for dogs" led her to "notice once again the 'real thing' in old and decaying trees."[13] Her first tree sculpture, initially called *Mor* and then *Raging Tree* (see figure 7), began with a 1983 visit to a quarry, where she watched men trying to burn a fallen tree. It wouldn't burn. She put its scorched carcass on a flatbed truck, took it home, and laid it in the garden just outside her studio. Three years later, she reversed it and stood it on its limbs, clamped snowmobile treads around them, just below its blistered head, and leaned its huge body forward, so that it seemed to be straining to liberate itself from the chains confining it to the wall and floor.

> Since 1983 I have been bringing trees into the studio and highlighting the relationships that they portray to other things in nature. I gut them, polish them, arrange them, sometimes even paint them to bring out these repeating forms common to us all. Trees are seen in forests or as timber or as furniture, but how seldom we see them as reflections of ourselves. How seldom, I believe, we see in each other what we have in common with the formation of the tree.[14]

13

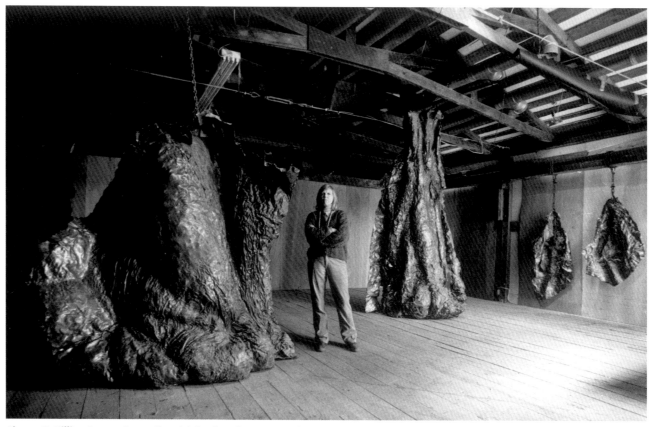

Figure 6. Gillian Jagger in studio with lead sculptures: *Dochas, Fhatast, Scath I and II*, 1991, lead, epoxy, paint.

In 1996, Jagger began choreographing open, dreamlike, animal-based installations of which *Rift* (1999), with its meandering swirl of deer and horse bones, mummified cats, obsolete farm implements, and other evidence of rural and geological disposal operations, is the grandest (see figure 8 and cat. 19). Elaborating on its formation and effect, she evoked an encompassing interconnectedness. Everything is "just a piece of that movement of the whole, and I'm just a piece of that whole."

II

Jagger's work seems unabashedly heroic. Her sculptures and installations are *big*—big in size, big in feeling, big in energy and flow. They are unconditional in their resistance to preciosity and affectation and in their refusal to conform to anyone else's expectations. Jagger does not make art with exhibitions in mind: her 1998, 1999, and 2002 Manhattan shows resulted from studio visits by the art dealer Phyllis Kind, who, after seeing her installations, invited her to show them in her SoHo gallery. Her refusal to make work that assumes the clean, well-mannered whiteness of most galleries and museums as its logical home, or that confers class status on its owner through an aura of polish or control, also leaves no doubt about her wariness of the art world system. She has said she is "afraid of belonging" to this system and that "it frightens" her to think of moving her work from the rough and tumble barns in which she makes them into commercial or institutional spaces. Not only do her tenuous and unwieldy sculptures and installations make little or no concession to collector or curatorial convenience, but in their aversion to the speed

and seamlessness of Internet technology and cellular culture—and in their affirmation of the value of time, effort, labor, work, and *inconvenience*—Jagger seems to stand outside the moment in which she lives. Her art could hardly be more uncompromising and absolute.

The most overtly heroic of Jagger's sculptures are those that were inspired by tree trunks, most of which she found on or near her twenty-acre property. Whether already fallen or about to be cut down, they were precarious and expendable (see figure 9). Most are clearly old. Each seems to be a nexus of stories: those of its own growth and decay and those of its complex interactions with people. The stories of human intervention—the impact on them of farming and development, or of Jagger's finding them, hauling them home by tractor, setting them upright, sometimes hanging them from chains or meat hooks, and scraping, fumigating, shellacking, or painting them—are knowable. The stories of their birth and growth, and, for the most part, of their collapse, are probably not. Jagger's attention enables both the shared, interactive stories and their private stories to be experienced as narrative pressure, as speech flow. As a result of her hands-on listening to their big, damaged bodies, so similar to human bodies and yet so other, each trunk seems both battered and undefeated, exposed to savagery, even murderousness, and yet somehow beyond death.

As a description of her work, however, "heroic" is deceiving. Jagger's tree sculptures, like her life, do suggest the heroic survivor. Jagger does adhere to the romantic belief that artists must struggle with all their might against the callousness, carelessness, and narcissism that market- and media-driven society breed. When discussing her students at Pratt Institute, the art school in Brooklyn in which she has taught since 1968, she said she identified with their "struggle," adding: "I find that art student who's really dedicated to being an artist in today's world is heroic." But Jagger does not claim an exalted status for her own struggle and sees the modernist image of the artist-hero proclaiming his uniqueness as another manifestation of the narcissism and self-importance she wants no part of. "I hate the idea of ego," she has repeatedly said. One of the rea-

sons for her resistance to the art world is that its cult of naming and branding encourages pretense and self-satisfaction. "Did you see my work—and what a big artist I am!" she explained. "That always makes me uncomfortable."

What is "the opposite of that [ego]?" she has asked herself. "That would be to say, what do we all share that we can look at?" Although her work can be imposing, even in-your-face, it is also down-to-earth and modest. "I like the humble idea because it means there's a chance we'll actually see something. If I get myself all blown up, it'll be my view." In the course of discussing her students at Pratt, she used the word "humble" *together with* "heroic." "I think [these are] the most humble of people trying to reach for something that's almost impossible with almost no rewards at the end."[15]

Jagger's sculptures are as much antiheroic as heroic. The art critic John Perreault, who has been writing about her for forty years, was right when he said, "there is not one ounce of irony in Jagger's work." It is also true, however, that her work is pervaded by an incongruity that gives it a persistent and sometimes comical absurdity. For example, because the right leg of the headless and armless eleven-foot-tall *Aon* (1992; cat. 3) is a flimsy prosthetic-looking scrap, incapable of bearing weight, clearly disconnected from the hip it is bolted into, the figure could not walk. But its left foot is positioned in a way that suggests the first step in a tap or ballroom dance. This ungainly body, held upright by chains that both constrict it and allow it to stand, seems ready to party. In addition, although this elongated tree-figure is not likely to show up in an advertisement for St. Tropez or Club Med, *Aon* seems at ease with itself. Marked by abuse, if not barbarism, intimidating in size and rawness, *Aon* is wild, wounded, incorrigible, and preposterous. And totally unself-conscious. It does not have the capacity to be vain.

Compare Jagger's tree sculptures to Rodin's 1898 *Balzac*, one of the most emblematically heroic modernist sculptures (see figure 10). Set well off the ground on its plinth, *Balzac* is solitary and monolithically self-contained. The body concealed under the robe is a mass of energy mobilized into explosive com-

pactness against the onslaught of the world. The figure's power is associated with the genital projection pushing against the robe from inside. If Balzac is gripping his phallus, he is holding it in the same hand with which he writes. His artistic creativity is clearly identified with sexual and masculine potency. One of Rodin's achievements was to humanize his heroes—the head of *Balzac* is fretful, even poignant, as is the working-class head of his *Thinker*—which helps explain why Jagger admires him: She cited him, Brancusi, Matisse, and Giacometti as examples of artists who "felt art was there to help us in life."[16] Nevertheless, Rodin continued to identify heroism with besieged aloneness, force of ego, and the sexualized male body.

By contrast, Jagger's *Cloim (Reach)* (1995; cat. 4), like *Aon*, stands directly on the ground, in our space, and is informal in the intimacy of the two vertical gestures rising nearly fourteen feet high out of their common base—like two figures in conversation, or, perhaps with a nod towards Rodin's sculptures of vaultlike hands, like two upstretched arms. Unlike Rodin's *Balzac*, however, *Cloim* is not self-protective. While *Balzac* creates a desire to pull back or have the writer pull back his robe and leave his nudity as exposed as it is in many of Rodin's impudently conceived female figures, Jagger's sculpture-beings are naked. Some, including *Cloim*, with its V-shaped bark at the juncture of the rising verticals, seem almost exhibitionistic in their display of colossal female genitalia. What's more, their insides are visible. Because they do not establish a barrier between inside and outside and are therefore resolutely open, Jagger's tree sculptures are not assertions of individual power. They are social. They indicate a desire to join—to chat, dance, play, merge. Their gender is often unclear, which contributes to the sense that they have, in some sense, already merged. Despite its conspicuous vaginal form, the conversational relationship between the long vertical appendages make it hard to decide if *Cloim* is male, female, or both. While *Aon* can be experienced as female, largely because of the hint of female genitalia and breasts, it suggests a wounded soldier, and Jagger considers it male. Personality and sexuality are important to these sculptures but not gender boundaries or genius.

Stamina and grit are important as well, but so are chattiness, trust, and disclosure.

When audience questions are asked, the complexity of Jagger's "heroism" becomes clear. To whom is Jagger's sculpture presenting itself? On whom, or on what, do *Aon* and her other tree sculptures depend for their sense of self?

Their anthropomorphism and location directly on the floor, in our space, anchor Jagger's sculptures in the human world. The openness and susceptibility of her unidealized sculptural bodies invite emotional and physical engagement. But because of their size and the trajectory of their gazes—in other words, the height at which the tops of the sculptures imply tracks of attention—the tree sculptures seem not to look at us but beyond us. As available and sociable as they are then, and as eager for exchange with us, in our shared space, they also seem to be in communication with something outside our vision. What's more, *Aon* and *Cloim* would not seem so secure with themselves and their conditions if they were not convinced that this other reality had already embraced them in all their absurdity and misfittedness. And that it has them in its best interests. So while the tree sculptures may resemble us, beckon to us, and be protagonists in our histories and stories, the first audience for which they perform, and exist, seems to be an other reality, present but absent, to which they belong as much as they belong to us. Their independence therefore presumes their dependence. Their undefensiveness about their susceptibility presumes faith in an encompassing interconnective system. It is this other reality and system, as much as the disjunctiveness and need of our everyday world, that Jagger's tree sculptures evoke.

III

One of Jagger's essential acts, perhaps her first creative act, is finding. She did not seek out the trees that are the basis of her wood sculptures, the roadkill deer that became the centerpiece of *Matrice* (1997–1998; cat. 11), or the buried cats and bones with which *Rift* (1999; cat. 19) began. She discovered

them by chance. The impact of her work depends upon the psychological and imaginative processes that enable, and are then set in motion by, this accidental and yet binding finding.

When Jagger comes across that tree or deer, the encounter is a shock. Her visceral attachment indicates to her a bodily recognition of a concentration of violent events. One is the death, usually senseless, of the tree or animal. Another is the act of walking away and disregarding that death. These events touch traumatic events in Jagger's life, reactivating them in the present. Her attachment to the unexpected and to her inescapable found evidence announces to her not just the urgency but also the density of the encounter. It lets her know something is at stake for her in engaging that evidence in ways that allow her to respond to the call that seems to be issuing from that dramatic convergence.

Jagger's engagement is physical, emotional, and intellectual. After finding the deer in *Matrice*, she turned it over and felt its limbs and ribs, and its weight and stiffness, before wrapping it and driving it home. When she discovered the skeletons in the pit near the Catskill Game Farm, the stench drove other people away, but she pulled them out, dragged them back to her truck, and took them to her barn. In each instance, she lived for an extended period with this evidence of disregard, examining and testing it in combination with other materials and evidence, surrounding it with other sculptures and absorbing it into the rhythms of her everyday life. While her engagement with found evidence always begins with immediate shock and attachment and evolves through sudden intuitions, it is equally defined by unshakable patience, and, with it, an understanding that hearing the call and making art require commitment in and to time.

After Jagger places the trees, cats, or deer in a barn, and the events that coalesced in her attachment to them begin to unfold, something usually happens in her everyday life that functions as an additional shock that makes possible the conversion of the found evidence into art. After living with the bones and cats in what would become *Rift*, Jagger suspended them from wires and left them for a couple of weeks. "I started getting the ani-

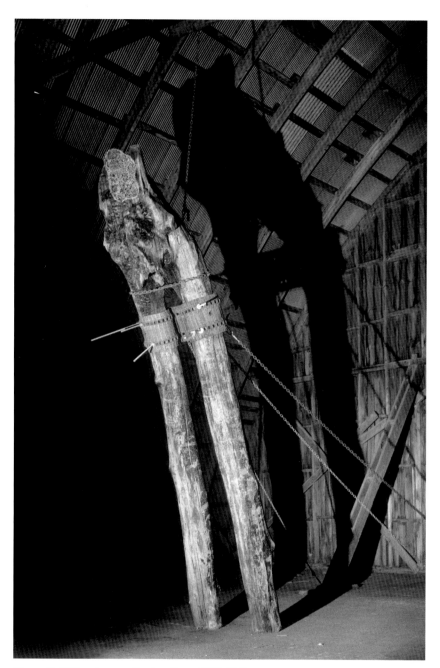

Figure 7. Gillian Jagger, *Raging Tree*, 1983–1986.

mals and feeling close to the bones, and the space between the bones," Jagger said. "I had a number of bone animals and I was putting them up and they looked so nice." Then she visited England for the first

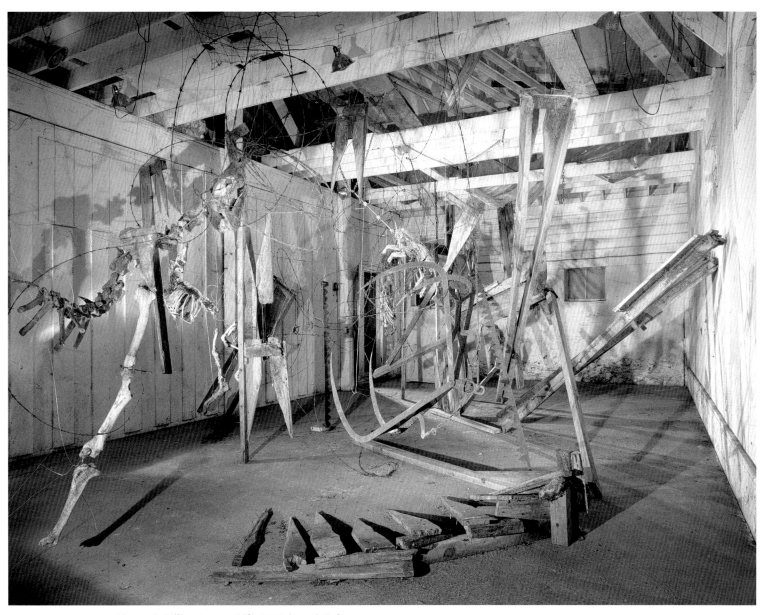

Figure 8. Gillian Jagger, *Rift*, 1999, in artist's barn.

time since her mother's death in 1997. When she returned, the work looked different. "I went to Europe and came back and thought, what is all this ditzy stuff I've got here." The cats and bones now seemed to her "tiny little bits."[17] She knew instantly what she needed and went after it with a fury that would lead her to use the word "tussle" to describe the yanking of wooden stanchions whose gently rounded inner rims had been eroded by the wear of the animal bodies squeezed within them. "I remember going to get the cow stanchions and ripping them off the wall, feeling them out, having a terrible time dragging them to the other barn, and hang-

ing them up amongst the animals and started to feel relief."[18] With the ripped out stanchions echoing and balancing the wildness of the discarded animals and bones, the "noise" of the "tiny little bits" became notes, the found evidence was drawn into song.

If finding is the act that mobilizes Jagger's work process, losing is the experience with which her art is perpetually coming to terms. She is open about the impact of loss on her art and life.

> I think that pain and loss, which seem to happen to all of us, are so intolerable. It happened to me very young. I lost my sister when I was ten. I lost my father when I was four. And the realization, not only did you lose but that you will lose again, because people die, no matter what else goes on, people die, has been a major, major element of my life. And I left England when the Second World War began, and I belonged in England, and I wanted to fight with England, and it at least gave me a place where I belonged, and to be dragged away, I remember that as a loss that nobody understood, and there's something about the cry that has stayed with me all my life as something that we all share. ... If you're not dealing with this, you're not dealing with anything. You're whistling in the wind. You've got to deal with it.[19]

Responding to the shock of encounter that attaches her to the deer, cats, and trees, and entering their histories, as well as the general histories of disregard and disrespect in human existence and throughout nature, Jagger also re-enters her own stories of rupture and neglect. The finality and yet the elusiveness of the narrative of violence to the cat or deer make her experience of violence activated by her encounters with them extreme—unresolvable—while at the same time making room in her response for her own story. By creating in and with these multiple histories, she does more than prevent her own trauma from inducing inertia and numbness. By transforming her encounters with that found evidence from shock to situation, she enables herself and others to become witnesses to those histories, and she makes room for a myriad of other stories.

Part of what makes her work so demanding is that Jagger incorporates actual animals and trees that once lived and are now dead. By spending time with them and allowing the activities of her hands and the pulse of her everyday life—and her feeling for materials and form—to permeate them, death is asserted and at the same time unfrozen. With the help of a sculptural language that includes bends and lifts, as well as swirls, meanders, and spirals, Jagger creates the sense that what has died is still in process, still in play. "There's a way to bring life into it, and that's movement," Jagger said. "You've got to catch the movement."[20] Discussing *Rift*, she said: everything is "in action, in movement. ...We're all in action all the time. We can't just isolate it. ...My way of getting that movement is visual movement and I can't do it with a single item." The care and eloquence with which her sculptural flows, like her sculptural bodies in flow, embrace and animate dead things, propose the confrontation with death as the *condition* of significant *living* communication.

The full implications of Jagger's aesthetic of finding can be suggested by a comparison of two terms. When asked about the "found object" and the effect of its histories on her sculptures and installations, Jagger bridled. "I've always jumped away from anything that sounds like an art term," she says. "I'm afraid of art jargon." "Found object" is the kind of term—"political art" is another—that, for her, makes art "single-minded." "I think things are so complicated and art is one of the very few things that can hold the complexity." One reason she does not like terms like "found object"—or why the word "political" "terrifies" her—is, she said, "because they shut it down."[21] For her the art world's obsession with categories and labels freezes movement. It's "like you're in the middle of feeling and touching something and suddenly they say, 'You know what this is?'"[22]

"Found object" is an institutional term familiar to anyone who has studied twentieth-century art. Its traditions began with Marcel Duchamp, who most famously took a urinal and a coat rack and presented them intact, unchanged, in a gallery, and with Pablo Picasso, whose Cubist collages and sculptures include objects like wallpaper and spoons. It became a decisive aesthetic term with André Breton and the Surrealists,

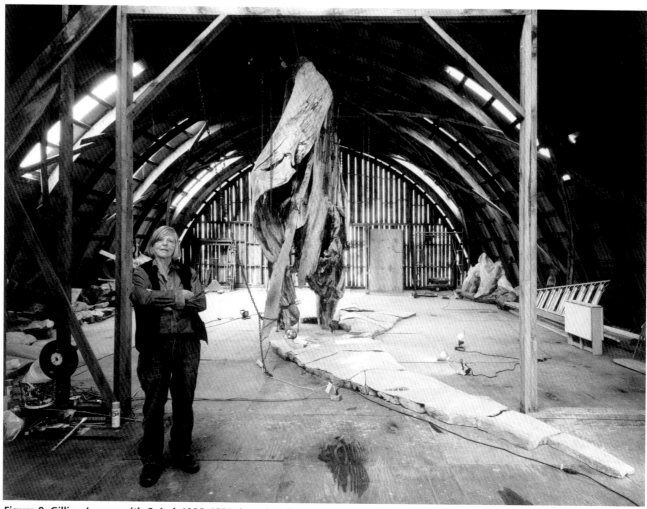

Figure 9. Gillian Jagger with *Spiral*, 1996–1999, in artist's barn.

for whom the fortuitous encounter with everyday objects exposed the inexhaustible current of desire in everyone that could charge an encounter with a cup or mask with the pleasure of discovery and will to possess. "Found object" is an urban and a consumer term. It suggests the mystery ever available in alleys, junk yards, apartment buildings, and department store windows. Its authority reflects the mystique of the flâneur, emblem of the modern city dweller, moving aimlessly yet expectantly through commodity-driven areas of the disruptively changing modern city, ever alert to the shock of the new and the marvelous. Whether the

"found object" is identified with awakening, debunking, longing, loving, provoking, salvaging, or scavenging, the term implies surprise and, with it, recognition and awareness. Because it tends to suggest that what we find is either expectantly waiting *for us* or given emotional and intellectual substance by the weight of the meaning *we bring to it*, the traditions of the "found object" underline the importance of the individual's meaning-making power. Over and beyond the reality of the object, or the power of Capitalism's diabolical machinery of desire, the term emphasizes *our* obsessions and desires.

While rejecting the appropriateness for her work of "found object," Jagger is comfortable with her own, related term. "Living in the country," she says, "I get closer than in the city to whatever I call that *found life* around me."[23] While "found life," too, emphasizes the importance of discovery and the meanings that can be drawn from our daily interactions with sufficient responsiveness, it is a rural term. It implies that whatever Jagger encounters in the landscape and then brings into her work is, in fact, *not* an *object* because it is *still* alive and part of something greater than itself. While the affection with which she used the term "found life" calls attention to the intensity and discernment of her desire, the word "life" subsumes her personal meaning-making machinery into a reality greater than her. While "found object" emphasizes the preeminence of the individual artist as the activator or maker of meaning, "found life" underlines the importance of respect, even reverence, for something of and yet beyond the individual. "Found object" emphasizes the subject. "Found life" resists control and ownership and argues for the possibility of subject-object intersection. It also implies that being an artist is a calling.

The connotations of "found life" explain Jagger's dismay at the Damien Hirst exhibition at SoHo's Gagosian Gallery that was one of the more publicized New York art world spectacles of 1996. The exhibition included one of the sliced cows and pigs in transparent Plexiglas vats of formaldehyde that helped make Hirst and other Young British Artists (YBA's) European and American art world sensations. Shaped by the smarter-than-thou hipness bred by many big-time art schools in Europe and the United States and pitilessly realistic in its assertion that that any idealization of farm life at the end of the twentieth-century is pathetically nostalgic and romantic, Hirst's exhibition embodied for Jagger many of the art world values she moved to the country in part to keep her distance from.

"I went to see Damien Hirst and had a fit of temper," she said. She couldn't "stand this thing." The work "made them [the animals] look like nothing and he's saying we're all indifferent and I'm not indifferent." The audience reaction jolted her as well. "People were laughing. They were walking through the show and smiling, nice, young kids, grinning at each other. I was horrified. It was like everything was a joke; there was no feeling. The animal, even though it was there, had nothing to say, couldn't talk."

When she got back upstate, she concentrated on the deer she had found in the underbrush by her property and then hung in her studio a couple of weeks earlier. "I came back up here thinking, I've got to cast the deer with the whole cry in it."

> When I went to cast it, I thought, Damien Hirst had turned that cow and pig into unfeeling, unsympathetic, unidentifiable products. And I wanted all that back. I wanted its pathos. I wanted its innocence. I wanted its dreaming quality that makes me think something is worthwhile in life. It's what I live for is what that deer has, and I left it alone."

Matrice, and with it her animal installations, was born. Its deer, suspended by chains strapped around its neck, resembles Hirst's dissected animals in that both inside and hide are visible. Unlike Hirst, however, whose chemicals and cuts made the insides of animals look as clinical and unhuman as frogs in a laboratory, Jagger exposes the deer's bone structure in a way that emphasizes its affinity with our own skeletons and with the skeletal structures of the cracked stone bending along the floor beneath the deer and with it of the body of the earth. *Matrice* includes a rebar grid cast from the intervals between the stones and four stanchions used to constrain cows all day, throughout their lives. "The cow stanchions are prisons," Jagger has said. "You open the top of it, and it opens wide, and then you clamp it on the neck, and you shut it down, and now the cow is stuck in it ... and that's how the cow lives."[24]

Despite his derisive and occasionally poignant irony, Hirst has made aesthetic products that profit from the dehumanizing practices of big cattle- and beef-raising factory farms. Jagger does not exploit the deer and its violent death. Unlike Hirst's animals, those in her work, like her trees, struggle. In expressing that struggle, she gives their bodies voice. Hirst embalmed his animals in chemicals and plastic and made it impossible to touch them; there is a clear sense that he never put his hands

on their bodies. Jagger's work is antiphobic: just as clearly, she touched every inch of the deer's body. The primary gesture of *Matrice* and *Rift* is parting—in the double sense of departure and *loss*, of separation and *release*. She creates a sense of stretching, lifting, making room, letting go. Like the mouth of one of the cats and jaws in *Rift*, the entire configurations seem to open slowly and remain open in speech or scream. The installations seem to be opening up to something, which invokes as a reality the as-yet-formed, the not-yet-final. Because of the parting stanchions, both works suggest that the terrible metal clasps that once imprisoned cows are now functioning with the well-being of the deer in mind. The hung deer seems to be performing on the gallows, and its performance seems appreciated. Once lost, the animals seem found. Embracing the term "found life" places a responsibility on Jagger to subordinate herself to the evidence she encounters and hints at the possibility of access to an ensouled interconnectedness in the fulfillment of that responsibility. "Found life" is a spiritual and ethical term. "Found object" is not.

IV

Jagger is an artist of association, not dissociation, and integration, not compartmentalization. Alienation from the means of production disturbs her. One reason why farmers were for many years a model for her was that she believed their discipline and labor enabled them to inhabit their processes of production and by so doing appreciate the materialization of food and how the machines that planted and harvested it, and machines in general, worked. "I don't like the world we live in, where we don't know what we eat," Jagger said. She believes indifference to the plight of farm animals, or indeed to any form of life that human beings depend on, encourages disconnection and exploitation. For their sake and ours she believes, "it is terribly important that these animals are not tortured, that they have good lives and have free range." [25]

The immediacy and flow of Jagger's words leave no doubt about her resistance to objectification. In her wall label for *Absence of Faith (Faith I and II)* (cat. 30),

she makes detachment virtually impossible.

At 9:45 a.m. February 16, 2000 Faith died. The vet took 45 minutes to find a vein. She had apparently impaled herself on a 4 x 4-inch post and bled. She finally freed herself by breaking the fence and returned to her stall. She could not walk out. She died in her stall. We removed her by tractor as she lay on an aluminum gate. The other horses kept screaming. She was the herd leader. We had to hide her from them on the other side of the house out of their view. She lay there all day. The ice was too severe on the drive to take her away. I cast her as she lay there. My friend who came for a forgotten coat helped me. It was too cold for the plaster to cure properly. It stuck to her hair. We did not have an isolator. We pulled off crumbling pieces. Months later I put the rubble together and made *Faith I*, and much later from the same rubble I cast *Faith II*. *Faith II* has a tiny piece of the original rubble that was the mold. It has on it a splatter stain of the blood. [26]

Jagger's remarkable dialogues with art history are shaped by her refusal of distance. She has "always loved" cave painting. [27] The animals that have survived for millenniums in the underground cave of Lascaux, in southwestern France, whose discovery in 1940 was an event of momentous cultural importance, are among many cave paintings that reveal the eternal human fascination with the tracks and rituals of animals and the enduring human need to participate in landscape by visually marking it. Jagger's *Running Deer* (2000) evokes cave paintings in the speed with which her animal seems to be hurtling through space and in its elegant and calm silhouette. But Jagger has included an actual animal, a deer that she found discarded in a black garbage bag suspiciously dumped by the side of the road not long after she heard shots from hunting rifles, off season. Its antlers had been sawed off its skull. In addition, like so many other works by someone for whom Greenbergian purity, or medium specificity—which shaped much of the art discourse in New York during Jagger's first decade there—is another form of compartmentalization, *Running Deer* mixes painting, sculpture (high and low relief) and collage. Most important, Jagger creates a tension between painted silhou-

ette and the actual body, which is both affixed to the wood surface and in the process of peeling off its shadow. While the essentially monochromatic silhouette is quietly pastoral, the real deer, with conspicuous antlers that Jagger found in a neighbor's workshop, looks feral, so much wilder than its painted shadow that the eight-foot-long rectangle of the pictorial surface seems to have no chance to contain it.

Pregnant Deer (2001; cat. 23), a plaster sculpture of a solitary deer lying on the floor, on its side and back, its back legs splayed, was inspired by an encounter with yet another roadkill deer. "She must have been hit in the night on the road," Jagger wrote. "She lay on her back with her leg up against the guardrail. Her nipples were waxy. I felt the head of the baby through her skin. She was cold and damp. I cast her as I found her."[28] The sculpture has something of the feeling of the gypsum Assyrian lion reliefs in the British Museum—so important to Jagger's father as well—including the famous one of a lioness downed by arrows, trying to hold herself alive while hunted for sport by the royal family. Jagger's white plaster deer is more spectral than those wounded creatures yet also more physical and abrupt, since it is based on a cast from an actual animal and presented by itself in our space. In his 1932 sculpture, *Woman with Her Throat Cut*, Alberto Giacometti set his violated yet still generative female figure directly on the floor, separated its legs and arched its stomach so as to make it both inviting handle and pregnant belly. Circulating around it, like circulating around *Pregnant Deer*—Jagger's sculptures keep us in perpetual movement—the viewer inevitably finds him- or herself standing between the deer's splayed legs. *Pregnant Deer* makes spectatorial distance almost shameful by inducing in the viewer a sense of participation in an event that, like the defining event in the Giacometti, seems both rape and murder.

In *Absence of Faith I and II*, the horse's head has a sculptural precision that suggests the muscularly sculptural horse heads in the Parthenon frieze, also at the British Museum. But here, too, Jagger's sculpture was cast from an actual animal, and far from being carved in marble, it, like the installation as a whole, is frail. As with *Running Deer* and *Kicking Deer* (2000; cat. 20),

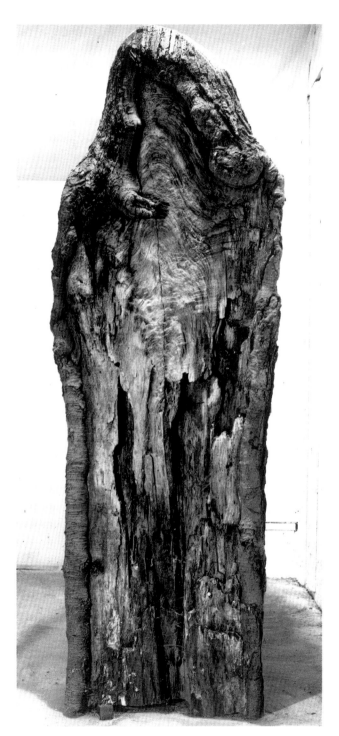

Figure 10. Gillian Jagger, *Te*, 1992, wood, 9 x 3 x 2 ft.

Jagger linked the animal to an accompanying relief structure, in this case a corral-like wall to which the horse is attached by wires. But she separated the horse from its framing ground, so that it seems to be parting and departing in our space. In addition, the ghostly emblem of her beloved horse ("horses are enlarged people," Jagger has said) is constructed with a negligible array of scraps of the plaster mold cast from her dead body.[29] The negative spaces between and inside the plaster fragments are markers of both irreversible disintegration and of agency—of Faith's spirit attaining release. They are also an invitation to enter the sculptural interior with our hands and head. More than *Matrice, Rift,* and *Spiral* (1996–1999; cat. 8)—in which the force of the sculptural lift makes it seem as if the animals or trees held up by chains or wires are incapable of falling—*Absence of Faith* seems suspended between deliverance and collapse. The horse is dead and living. Its body is giving way, becoming lost. As her spirit struggles for release, it becomes presence and is found. Faith is not object but subject. It is hard, if not impossible, to feel detached from her death and life.

Jagger's commitment not only to Faith but also to the found evidence to which she feels attached is a response to a call. In her drawings, pastels, charcoals, and some of her modeled or tree-shard sculptures of horse heads, the call is unmistakable. In *Daedalus* (2001; cat. 28), *Cara* (2001; cat. 29) and *Horse Eye I* (1995; cat. 5), *Horse Eye II* (2001; cat. 26), and *Horse Eye III* (2002; cat. 32), the eyes, or, more often the single eye, has a commanding, if not a beseeching intensity. Discussing the responsibility to the "face of the other," the French philosopher Emmanuel Lévinas described the "encounter" with this face as "a demand and an order."[30] It is, he said, "an appeal addressed to me."[31] "The true ego is the ego which discovers itself precisely in the urgency of responding to a call."[32] The eyes in almost all Jagger's horses' heads, even those in the tree shards suggested by empty, "blind" sockets, seem to emanate a desire and an aloneness that cannot and must not be resisted. The eyes do not hide the excessiveness, even the wild-

ness, of their need. The call that attaches Jagger to these animals and trees, and is then uttered in her sculpture, is a cry.

In the presence of this vulnerability and struggle, Jagger does not shut her ears and eyes. Discussing "the passage to the human," Lévinas mentions the importance of "the discovery of the death of the other, of his defenselessness and of the nudity of his face." He goes on to say: "This discovery of his death, or this hearing of his call, I term the face of the other. Dis-interestedness is taking on oneself the being of the other. I also term this 'responsibility.' Responsibility is the first language."[33] This responsibility to the other in its difference and death has nothing earnest, self-righteous or measured about it. It cannot be explained by guilt. Far from narrowing the artistic imagination into a vehicle of correct and dutiful behavior, this responsibility is passionate and perilous in its disruption of the self's mythology of control. The intensity and devotion of a responsibility that accepts the "fundamental asymmetry," to use Lévinas's words, of the relationship with the other, and the obligation to relate to the other in its defenselessness and chaos as subject, leads to experiences of boundlessness and passage.[34] "Responsibility is transcendence from one to the other," Lévinas said, "the uniqueness of a rapport going from the unique to the unique. Responsibility in effect is inalienable: the responsible self is no longer the self closest to the self, but the first one called. Unique as elected."[35] Responsibility to the call of the other, and building and maintaining the passage to the other that are part of the fulfilling of this responsibility, enable the human to exist.

How does Jagger's art define responsibility?

Her responses to found life begin with a visceral awareness of the urgency of its vulnerability or death and include a passionately attentive listening that has a visceral as well as a meditative component. This listening to the other's call precludes self-absorption and narcissism, which dissolves defenses against one's own anxiety about vulnerability and death that help produce the mentality of compartmentalization. It also

precludes phobias about the body or difference, or obedience to the authority of the hidden. Jagger's response is an embrace that is total without being possessive. What she finds becomes her art in the process of immersing herself in and remaining open to it in its, and her own, emergency. This requires a continuing extension and generosity toward what is not her, a caring for the other in its imperiled state that binds her to it and the rest of the world around her in a way that distinguishes human beings, and the human, from the rest of nature.

Jagger's responsibility does not permit a belief in the superiority of one race over the other. "I don't believe in mastery," Jagger has said. "I believe in adaptation." Presented with the argument that because of expanding deer populations in the eastern United States, many deer must be killed for their own good, as well as for the good of the property of human beings whose cars they dent and gardens they invade, Jagger replied:

> My interest is to keep them in the world with me, to give myself the discomfort of thinking how to live next to them when they're taking my flowers, to think about how to handle them but not destroy them. Not to say, well I'm much more important than they are, they're not allowed here, I can shoot them. And I think my business now is to adapt, and all of our business now is to adapt and try to get on with each other.[36]

The human in Jagger, as in Lévinas, does not expect reciprocity. In the urgency of her commitment to Faith or to her found life, she does not ask: What's in it for me? How can I profit from this? Her response without expectation is the antithesis of the quid pro quo that is the staple of political and business relations. It brings to mind the actions of the Médecins Sans Frontières (MSF or Doctors Without Borders), the NGO that was awarded the Nobel Peace Prize in 1999. In his acceptance speech, James Orbinski spoke of the organization's commitment to the "dignity of the excluded," "the dignity of people in crisis." "Our action and our voice is an act of indignation, a refusal to accept an active or passive assault on the other,"

he said, expressing himself with words that categorically rejected any distancing language that denied the immediacy of the humanitarian emergencies around the world to which MSF was called on to respond. "And ours is an ethic of refusal," Orbinski said. "It will not allow any moral political failure or injustice to be sanitized or cleansed of its meaning." He also said: "The humanitarian act is the most apolitical of all acts, but if actions and its morality are taken seriously, it has the most profound of political implications."[37] Jagger dislikes the term "political art," with its overtones of finger-pointing, orthodoxies, and good conscience, but if the implications of her aesthetics are taken seriously, it is clear that the politics of her art are profound and radical.[38]

Jagger follows the shadows and tracks of what was there and is there no longer, exposes the consequences of carelessness and neglect, finds the dignity of struggle everywhere. Responding to the intensity of the call in that horse's eye, in that fallen tree, in those bones and cats, she finds links between their bodies, the human body, and the body of nature. Through her sustained attention to those tracks and calls, and to the other in crisis, Jagger proposes an aesthetic space in which human beings can find one another without defenses and communicate without posturing and domination. Contrary to all traditions of statuary, including her father's, Jagger's sculpture offers no reassurance of stability or safety. Almost everything in her work—even the thickest tree trunks—is unstable. *Matrice*, *Rift,* and *Absence of Faith* could be cut down by a nail cutter. Some of her trees are crumbling; many are susceptible to further decay. This tenuousness, as much as their unpretentiousness and openness, is part of their truth. If the wires were cut, the trees rotted, and the bones crumbled, it would not be like the vandalization of a Michelangelo or a Picasso masterpiece, or of some other priceless artistic property. It would seem distressing yet okay. For Jagger, vulnerability and death are conditions of the real, and the ethical is the condition of the visionary.

NOTES

1. All three quotations are taken from a public conversation between Gillian Jagger and me on December 5, 2002, at the Elvehjem Museum of Art. If a quote is not cited immediately, its source is provided in the next footnote.

2. Interviews with Gillian Jagger December 27 and December 30, 2002. Biographical information is taken from these interviews.

3. Elvehjem conversation.

4. December 2002 interviews.

5. Elvehjem conversation.

6. "Narrative of a Work: Gillian Jagger on *Matrice*, interviewed by Michael Brenson," accompanying Jagger's 1998 exhibition at the Phyllis Kind Gallery.

7. Elvehjem conversation. The performance artist Laurie Anderson recently described the early and mid-seventies in a similar way. During this time, she said, "the art scene was about paying very close attention, recognizing and using shapes and forms that were already there rather than inventing brand new ones, using tools in new ways." Laurie Anderson, "Time and Beauty," from the forthcoming book *In the Space of Art: Buddha Mind and the Culture of Now*, ed. Jacquelynn Baas and Mary Jane Jacob (Berkeley: University of California Press, 2004).

8. Wall label for *The Art of Gillian Jagger*, an exhibition at the Elvehjem Museum of Art from November 23, 2002 through January 19, 2003. Jagger wrote the wall labels describing the works.

9. These concerns are among those outlined in the introduction to *The Power of Feminist Art: The American Movement of the 1970s, History and Impact*, ed. Norma Broude and Mary D. Garrard (New York: Abrams, 1994).

10. See Lucy R. Lippard, *Overlay: Contemporary Art and the Art of Prehistory* (New York: Pantheon, 1983), Jagger is mentioned on pp. 36–37 and 142.

11. December 2002 interviews.

12. Elvehjem conversation.

13. December 2002 interviews.

14. Elvehjem wall label.

15. Elvehjem conversation.

16. See Barbara Gordon and Richard Schlesinger's video, "Casting Faith: A Portrait of Gillian Jagger," 2002.

17. Elvehjem conversation.

18. December 2002 interviews.

19. "Narrative of a Work."

20. December 2002 interviews.

21. Elvehjem conversation.

22. December 2002 interviews.

23. Elvehjem conversation.

24. "Narrative of a Work.

25. December 2002 interviews.

26. Elvehjem wall label.

27. December 2002 interviews.

28. Elvehjem wall label.

29. December 2002 interviews.

30. See *Is It Righteous to Be?: Interviews with Emmanuel Lévinas*, ed. Jill Robbins (Stanford, CA: Stanford University Press, 2001), 48.

31. *Is It Righteous to Be?,* 50.

32. *Is It Righteous to Be?*, 112.

33. *Is It Righteous to Be?*, 108.

34. *Is It Righteous to Be?,*54.

35. *Is It Righteous to Be?*, 108.

36. "Narrative of a Work."

37. James Orbinski, Nobel Lecture, December 10, 1999, available at *http://www.nobel.no/msf_999eng.html*

38. In Barbara Gordon and Richard Schlesinger's video, Phyllis Kind, whose support in the last five years has been crucial to Jagger's success, affectionately declared, in response to the recurrent question of the political in Jagger's work: "Everything Gill does is political ... She wants to change the world."

Artist's Statement

I believe that the way of perceiving that I have developed living in nature leads to a shared sense of wholeness, to a sense of in-commonness of our mutual inter-connected survival. My work tries to speak as part of something already existing, not as a product of something I 'made up.' My work has been one long search to find what really is common to us all in nature.

At first, in my sculpture during the sixties, I relied on observation and fact collection by casting everything I could in plaster, including parts of roads, tracks, footprints, manholes, and finally water, by adding cement to the downhill pour. The final appearance of these works caused me to notice the 'real thing' in rock formations. I removed sections of stones intact directly from quarries and kept the glacial original arrangement of parts by welding them together as I had found them. By the late eighties I began working with sheets of lead that I hung up and let slump into natural bulges, which I then backed with resin. The resulting formations caused me to notice once again the 'real thing' in old and decaying trees. Since 1985 I have been bringing trees into the studio and highlighting the relationships that they portray to other things in nature. I gut them, polish them, arrange them, sometimes even paint them to bring out these repeating forms common to us all. Trees are seen in forests or as timber or as furniture, but how seldom we see them as reflections of ourselves. How seldom, I believe, we see in each other what we have in common with the formation of the tree.

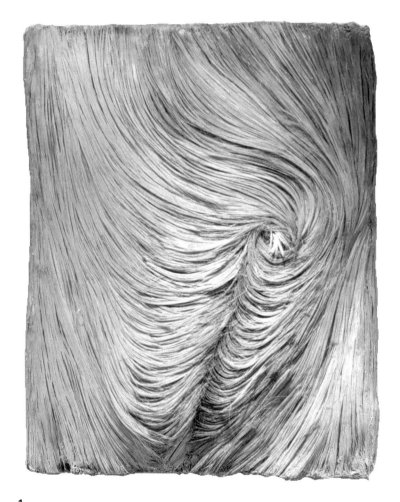

1
Whorl, 1974
Fiber, molding paste, paint, stain, 49 x 37 x 4 ¹/₂ inches

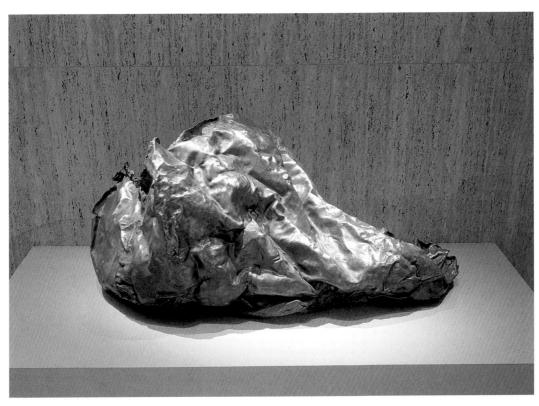

2
Eadan [The Brow], 1991
Lead, 26 x 57 x 27 inches

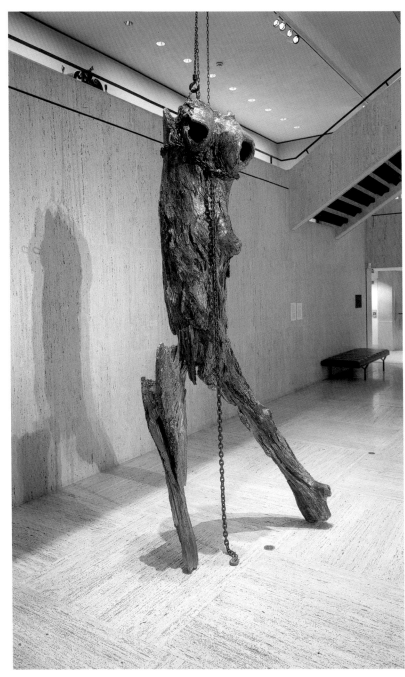

3
Aon, 1992
Wood, steel chains, 132 x 72 x 30 inches

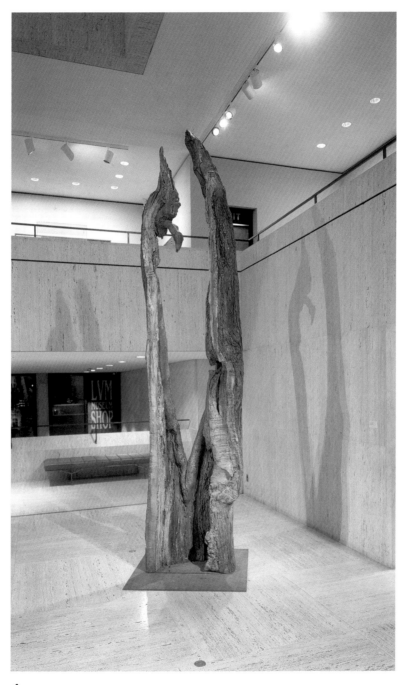

4
Cloim (*Reach*), 1995
Wood on steel base, 166 x 44 x 44 inches

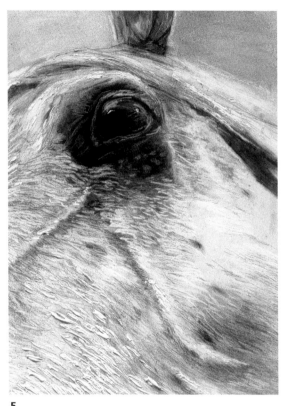

5
Horse Eye I, 1995
Pencil and paint on paper, 22 x 17 inches

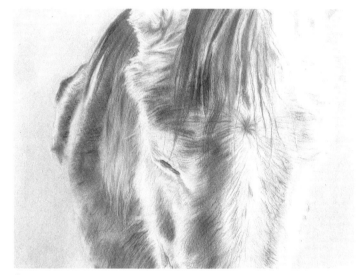

6
Sleeping Faith, 1996
Pastel on paper, 21 x 25 inches

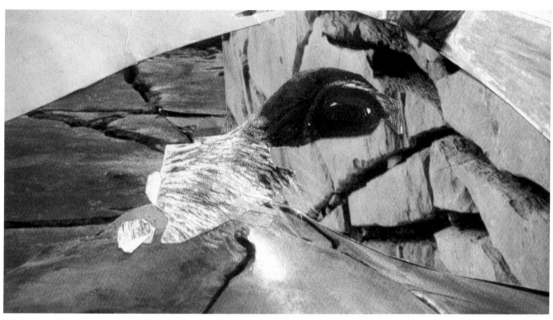

7
Rock Horse Head, 1996
Photocollage with drawing, 17 x 21 $^{1}/_{2}$ inches

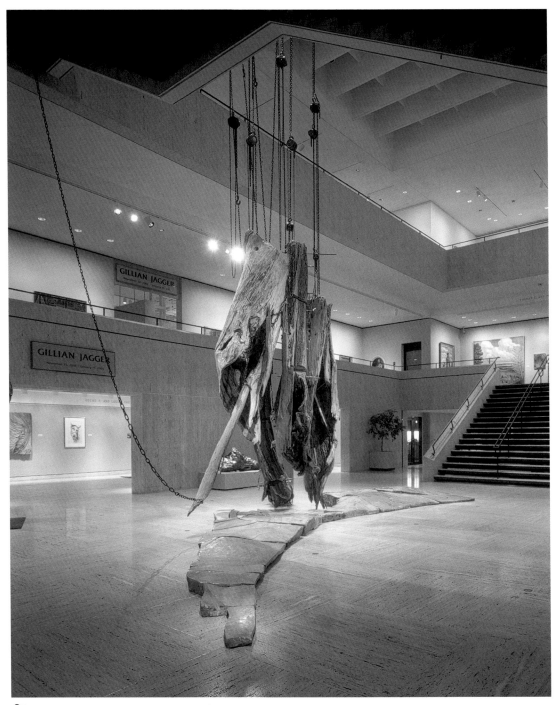

8a
Spiral, 1996–1999
Wood, cast rocks, grid, chains, hooks, pulleys, 480 x 144 x 336 inches

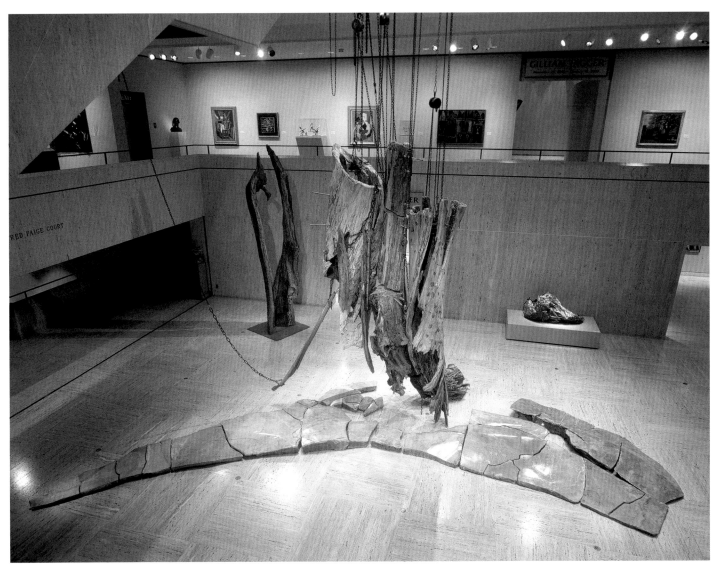

8b
Spiral, 1996–1999

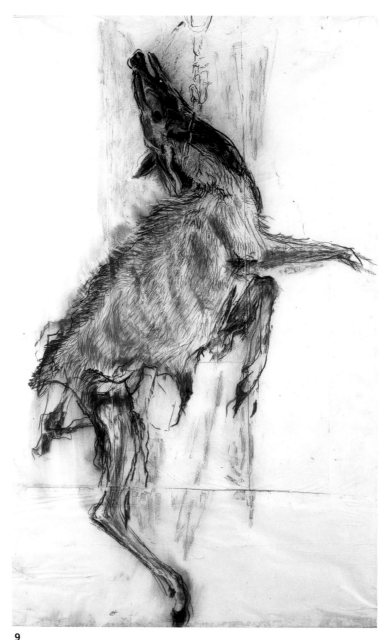

9
Hanging Deer I, 1997–1998
Conté crayon, pencil, charcoal on paper, 78 x 49 inches

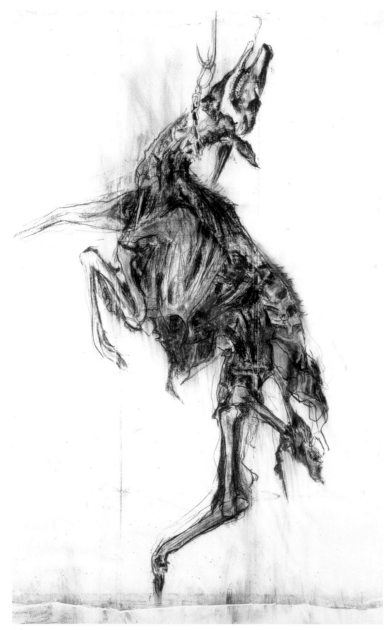

10
Hanging Deer II, 1997–1998
Conté crayon, pencil, charcoal on paper, 78 x 49 inches

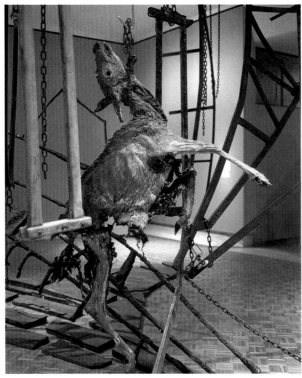

11a
Matrice, 1997–1998 (detail)

"I believe that art helps us with our living.

When the mouse does not come out of the mouse hole, the cat simply waits with patience and in silence. We, on the other hand, make up a dance while we wait. When we wake in the night overtaken by a terrible, unbearable feeling because a friend has died, one thing we can do is to go into the studio and work. When you call out asking what life is about and nothing comes back from the wind, I have discovered that by studying the wind itself that it makes a spiral, the river a meander, the trees branch as does a lighting bolt, and the surface of the earth cracks. These are in fact answers to my questions. They demonstrate to me our interconnectedness. We share the patterns. When I look at the body of a dead deer that I have found naturally mummified by the sun, lying ignored by passersby on the side of the road, and when I hang it in my studio as part of an installation, I see that I am connected to that deer. That in its death, it has preserved the image and the spirit of nature. Henry More (1614–1687), following Plato, called this "spirit of nature, soul of the world, the *anima mundi*." He felt that this mysterious power holds the world together. I have come to this same belief. "

Gillian Jagger

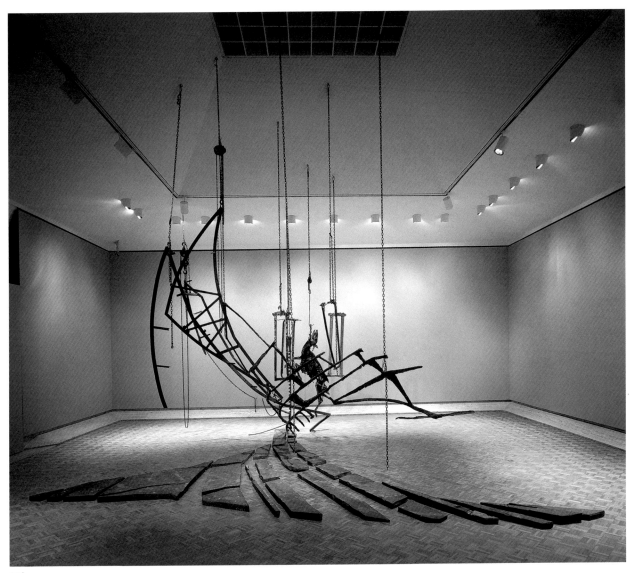

11b
Matrice, 1997–1998
Deer, stone, wax, wood and steel stanchions, chains, 168 x 300 x 216 inches

12
Racing Horse, 1998
Wood on steel base, 12 x 46 x 6 inches

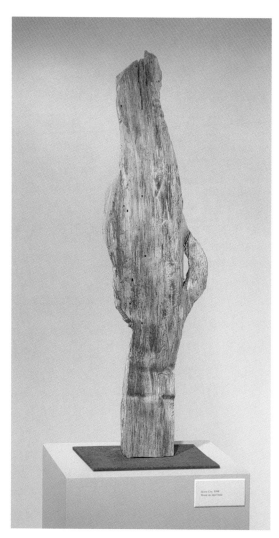

13
Horse Cry, 1998
Wood on steel base, 40 x 12 $^{1}/_{2}$ x 12 inches

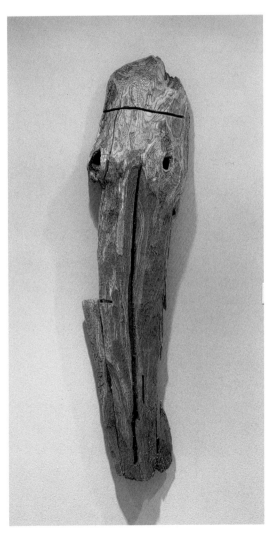

14
Wise Horse, 1998
Wood, 54 x 13 x 6 inches

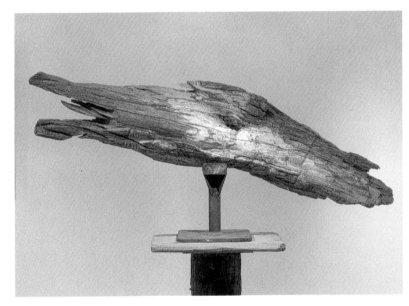

15
Crazy Horse, 1998
Wood on steel base, 26 x 64 x 13 inches

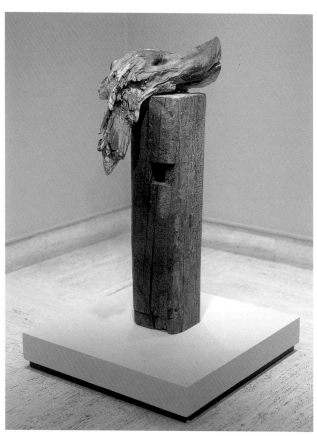

16
Dog's Head, 1998
Wood, 24 x 16 x 10 inches

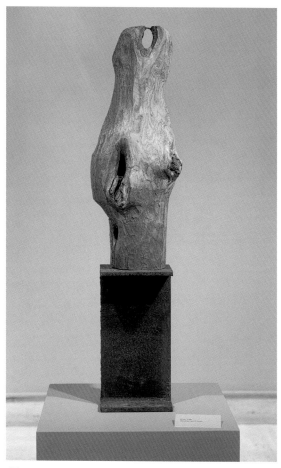

17
Hope, 1998
Wood on steel I-beam, 44 x 8 ¹/₂ x 7 inches

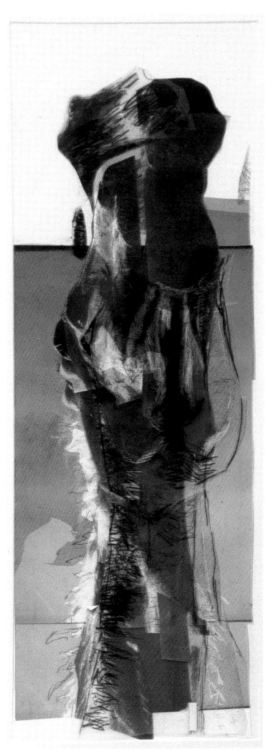

18
Horse Cry I, 1998
Photocollage, 39 ¹/₂ x 17 inches

The Animals

"I, in fact, see the soul of the world in a cat that, although now dead, fought to live with every ounce of her being and preserves the image of the spirit of nature for us to see. Both cats in *Rift* were found on or around my property. The one with the fur I found under the ice. The one with the preserved skin I found sunk in a bog of leaves in an old shed. The horse with a fairly intact torso and pelvic region was brought to me by a colleague at Pratt Institute, Lindsey Sweet. She had been keeping it on a fire escape in Chinatown. Originally she had found it in a snowy desert in New Mexico. In some cases I have put together bones from different animals that I cannot definitely identify. I have hung the bones with gaps between parts in the style of Egyptian reliefs that I have seen in museums. Years ago I cast animals I found dead in Africa and intended to create an Egyptian tomb by putting the casts together in walls surrounded by plaster. I never did it. Now I am hanging them in air. The deer piece is composed of a least three deer, head of one, leg of another, and leg and torso of another. The large animal at the back of *Rift* may be a zebra head and contains bones of other exotic animals. I found those bones on the property of Handelsman Manson, which backs up to the property of the Catskill Game Farm."

The Rest

"None of the wood in this piece is gratuitous. At one time a calf's head was perpetually held by each of those V-shaped items called stanchions, and the wood of each of these old stalls has been smoothed by the calf's rubbing—one after another—over hundreds of years. I think the barbed wire tells its own story; it is used in prisons but more often, always without regret or reserve, for animal husbandry.

"The Greek and Roman philosophers had a clear conception of natural as opposed to man-made law. They understood that people existed prior to government and any civil order and that animals had an inherent natural right to exist independent of government. Not so Western ethics. In Genesis, God gave humankind dominion over nature and the right to exploit it without restraint, and it is clear that the fundamental principles of law and justice as writ did not refer to either animals or the environment. In fact, in the seventeenth century unanesthetized animals were nailed to a board and cut up to advance medical science. As Roderick Frazier Nash explains in *The Rites of Nature*, animals 'were insensible, irrational machines, they moved like clocks . . . they could not feel pain. They were, in Descartes's sense of the term, unconscious. Humans, on the other hand, had souls and minds.' Thus: 'I think, therefore I am.'

"My recent work is concerned with what I see as a rift that has come between ourselves and nature. If we continue to care only about our own species, we will set ourselves adrift from the larger and necessary connective force of the whole, what Henry More (1614–1687) called the 'spirit of nature, soul of the world, the *anima mundi*.'"

Gillian Jagger

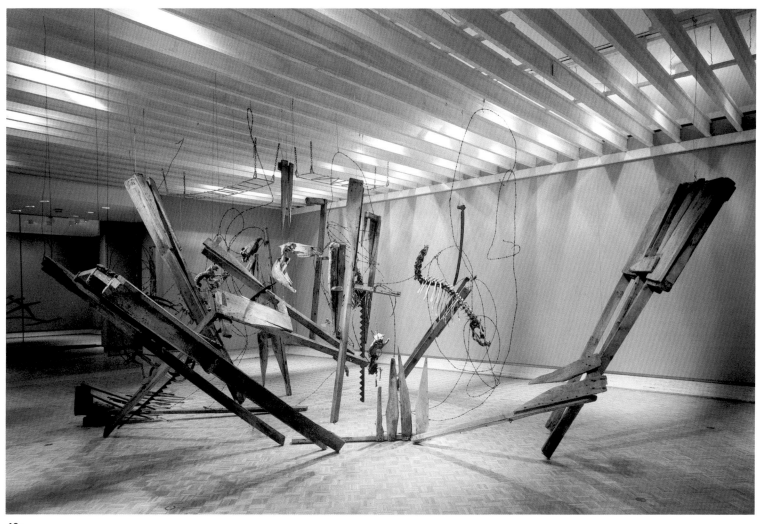

19a
Rift, 1999
Calf stanchions, animal bones, farm implements, barbed wire, 132 x 360 x 240 inches

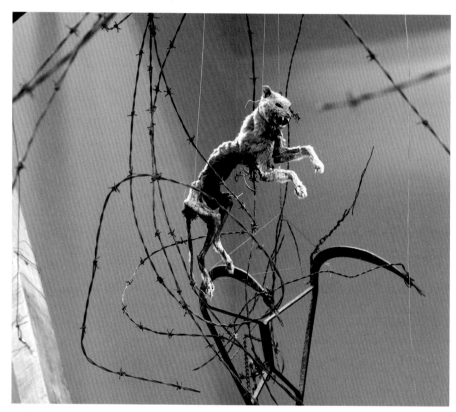

19b
Rift, 1999 (detail)

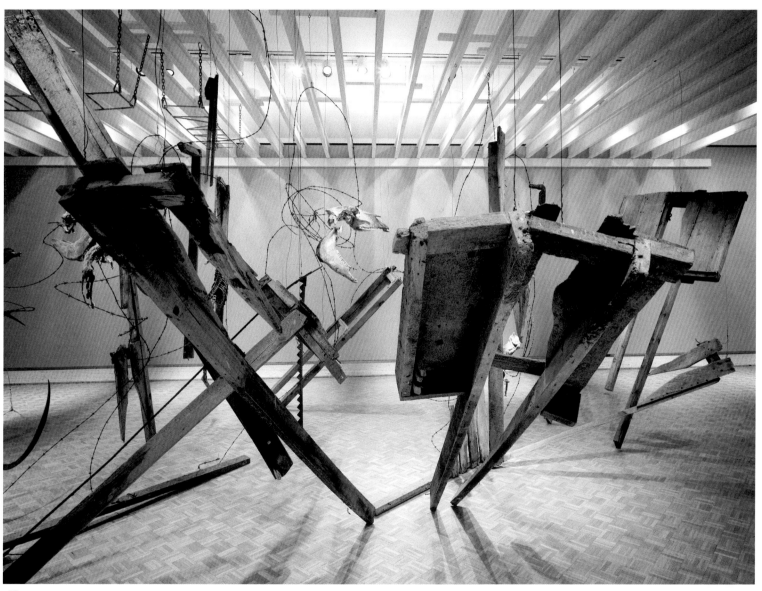

19c
Rift, 1999

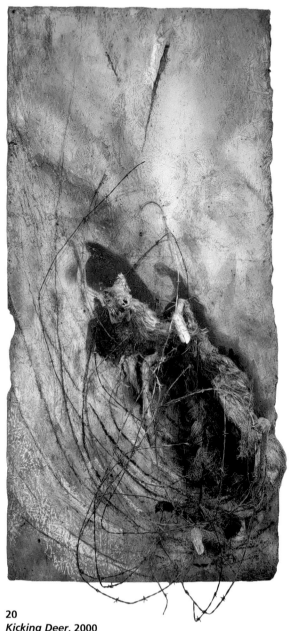

20
Kicking Deer, 2000
Deer, barbed wire, paint, ink, charcoal on pressed wood,
96 x 47 x 28 inches

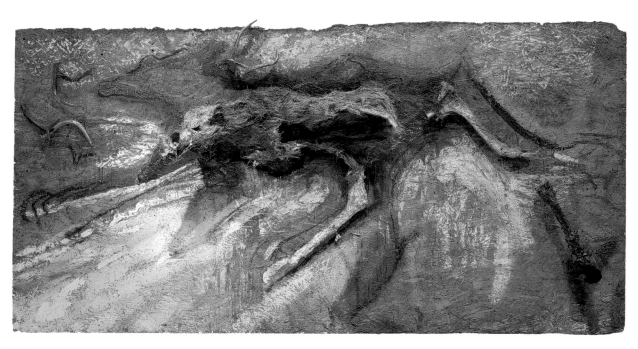

21
Running Deer, 2000
Deer, paint, plaster on pressed wood, 48 x 96 x 12 inches

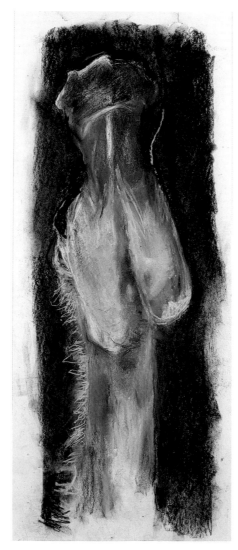

22
Horse Cry II, 2001
Pastel on paper, 41 $\frac{1}{2}$ x 23 inches

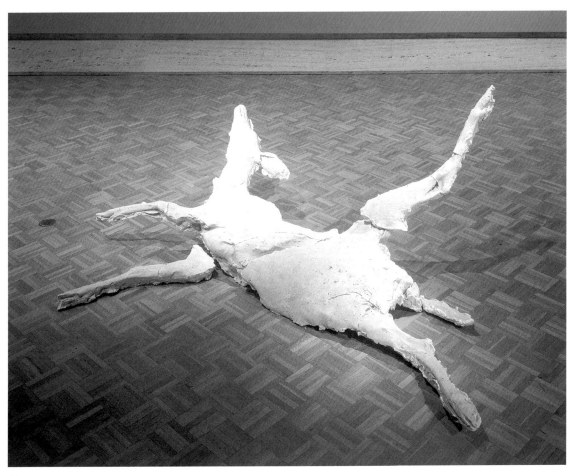

23
Pregnant Deer, 2001
Plaster, mixed media, 30 x 78 x 60 inches

"She must have been hit in the night on the road. She lay on her back with her leg up against the guardrail. Her nipples were waxy. I felt the head of the baby through her skin. She was cold and damp. I cast her as I found her."

Gillian Jagger

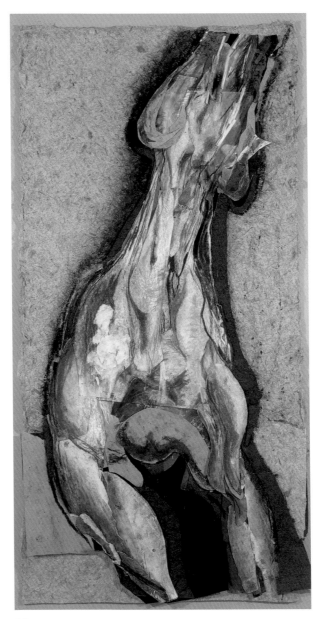

24
In Memory, 2001
Collage of paper and paint, 48 x 27 inches

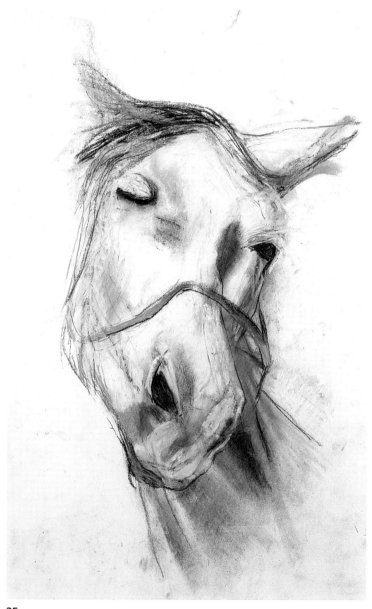

25
Faith's Head, 2001
Pencil and pastel on paper, 36 x 27 inches

26
Frightened Horse, 2001
Pastel on paper, 34 x 24 inches

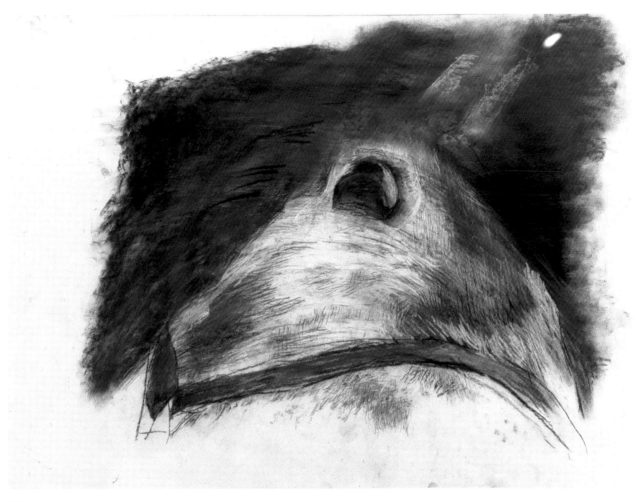

27
Horse Eye II, 2001
Pastel on paper, 24 x 34 inches

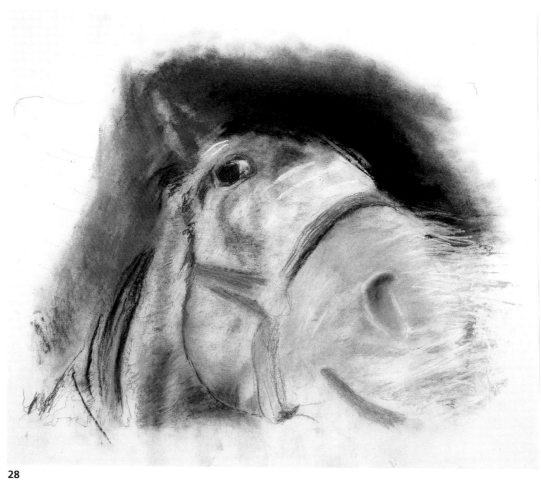

28
Daedalus, 2001
Pastel and pencil on paper, 30 x 34 inches

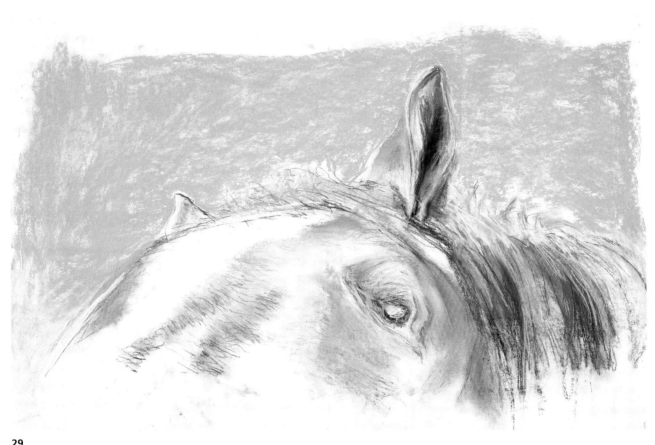

29
Cara, 2001
Pastel and pencil on paper, 31 x 44 inches

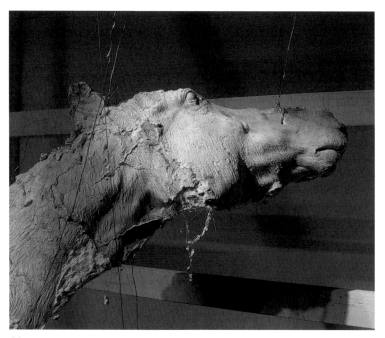

30a
Absence of Faith (Faith I and Faith II), 2001 (detail)

"At 9:45 a.m. February 16, 2000 Faith died. The vet took 45 minutes to find a vein. She had apparently impaled herself on a 4 x 4-inch post and bled. She finally freed herself by breaking the fence and returned to her stall. She could not walk out. She died in her stall. We removed her by tractor as she lay on an aluminum gate. The other horses kept screaming. She was the herd leader. We had to hide her from them on the other side of the house out of their view. She lay there all day. The ice was too severe on the drive to take her away. I cast her as she lay there. My friend who came for a forgotten coat helped me. It was too cold for the plaster to cure properly. It stuck to her hair. We did not have an isolator. We pulled off crumbling pieces.

"Months later I put the rubble together and made *Faith I*, and much later from the same rubble I cast *Faith II*. *Faith II* has a tiny piece of the original rubble that was the mold. It has on it a splatter stain of the blood."

Gillian Jagger

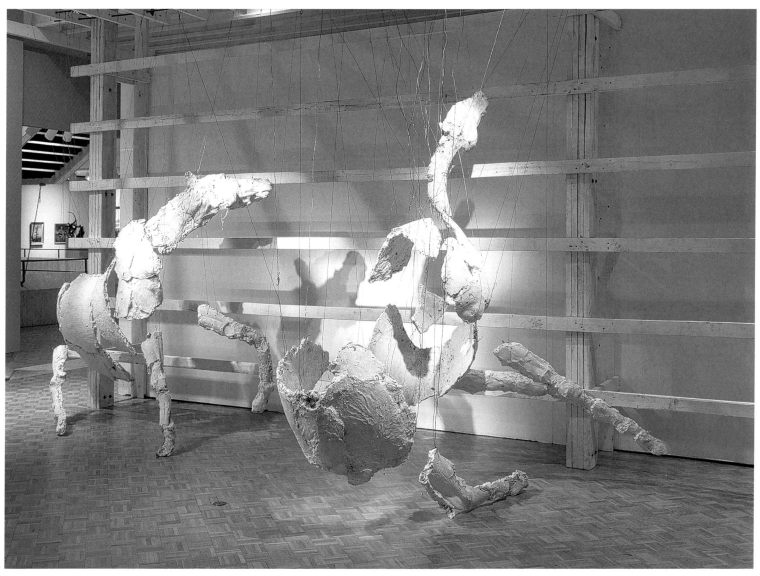

30b
Absence of Faith (*Faith I and Faith II*), 2001
Plaster, wire, mixed media, 144 x 240 x 168 inches

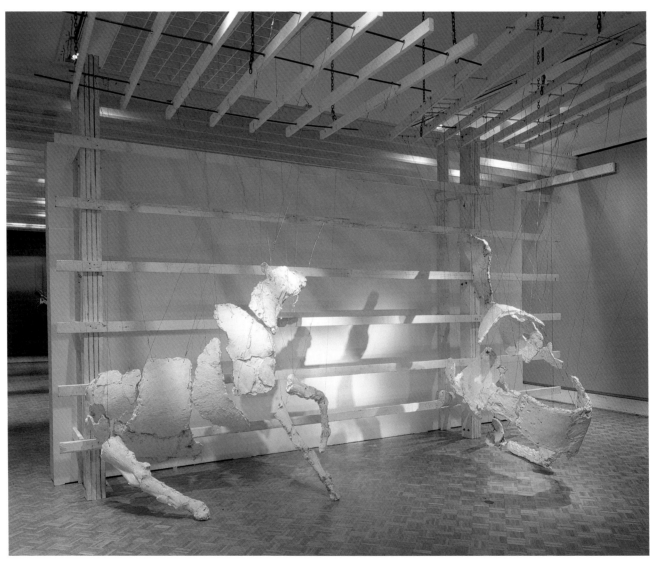

30c
Absence of Faith (Faith I and Faith II), 2001

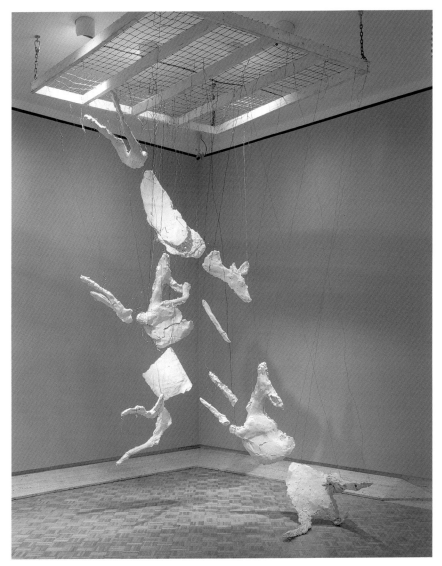

31
White Doe and Twins, 2002, Plaster, wood, wire, 154 x 84 x 84 inches

"This past fall, I thought about losses again. I had collected the casts of many parts of many deer by the roadside and fields near where I live in upstate New York. One day I hung the body of a deer upside down and thought about the conversation I had with my neighboring farmer that I couldn't get out of my mind.

'They shot the white doe.'
'Who did?'
'The hunters!'
'Your white doe? The one that always had twins?'
'Yes, she had the twins this year too.'
'How awful.'
'You know you never shoot the white deer. The Indians can tell you, they never shoot the white deer.'"

Gillian Jagger

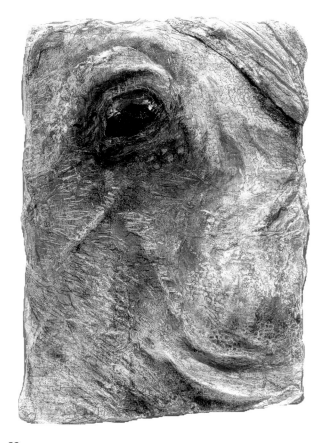

32
Horse Eye III, 2002
Paris Craft molding paste, paint, pastel, 24 x 18 x 3 $\frac{1}{2}$ inches

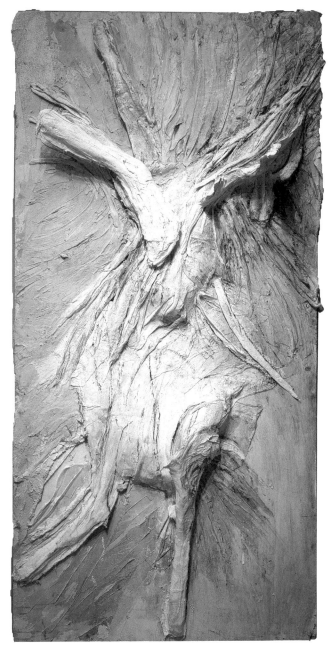

33
White Doe, 2002
Paris Craft molding paste, charcoal, paint, 96 x 48 x 12 inches

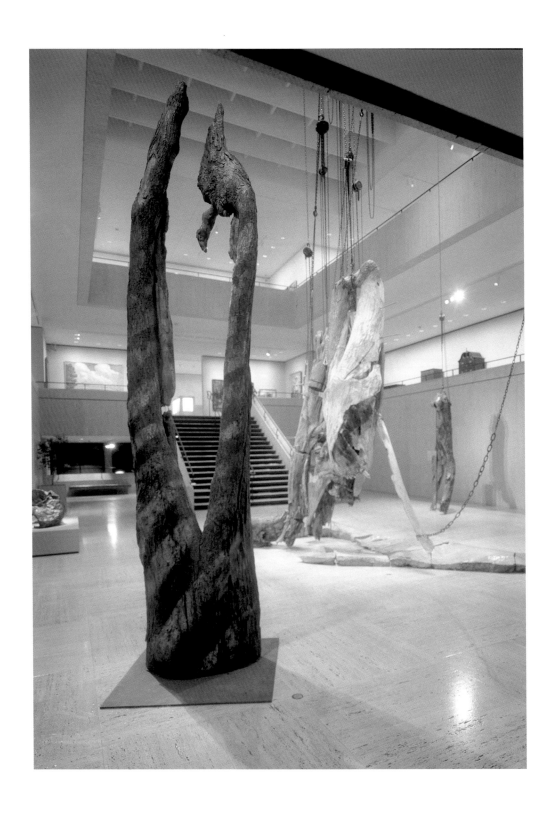

ARTIST'S BIOGRAPHY AND EXHIBITION HISTORY

Born 1930 London, England

Education
1953 B.F.A., Carnegie Mellon University, Pittsburgh, PA
1960 M.A., New York University, New York, NY

Academic Positions
1961–1968 Assistant Professor of Art, C. W. Post College of Long Island University, Brookville, NY
1968–present Professor of Art, Graduate School, Pratt Institute, Brooklyn, NY
1996–2000 Visiting Critic, Pennsylvania Academy of the Fine Arts, Philadelphia, PA

Grants and Awards
1967 Art Today, 1967, First Prize, New York State Fair, Syracuse, NY
1980 CAPS Grant (Creative Artists Public Service) Program-Sculpture
1983 John Simon Guggenheim Memorial Foundation Fellowship Grant
1985 New York Foundation for the Arts Grant
1985 Distinguished Professor Award, Pratt Institute
1993 The Louis Comfort Tiffany Foundation Grant
1994 Adolf and Esther Gottlieb Foundation, Inc. Grant

Public and Private Collections
The Charles Aldrich Museum of Contemporary Art, CT
The Charles Bronfman Collection, Montreal, Canada
Alexander Dashnaw, New York, NY
Mitzie Dobrin, Montreal, Canada
Finch College Museum of Art, New York, NY
Eamon Furlong, New York, NY
Edward Goodman, Palm Beach, FL
Marion Griffith, New York, NY
Hillwood Art Museum, C. W. Post College, Brookville, NY
Phyllis Kind, New York, NY
E. Leo Kolber, Montreal, Canada
Walter Liedtke, New York, NY
Linda Liebman, New York, NY
Mrs. John Lins, New York, NY
Rosemary McNamara, New York, NY
Bonnie Rabin, New York, NY
Debbie Reynolds and Carol Kautzman, New York, NY
Rockland County Community College, New York, NY
John Rosekrans's Runnymede Sculpture Farm, CA
Donald Noel Shaw, New York,
Robert Silver, New York, NY
Lynda Simmons, Colorado
Bernice Steinbaum, New York, NY
Carlton Varney, New York, NY
Edward Villela, Miami, FL
Arthur Weinstein, New York, NY

EXHIBITION HISTORY

Solo Exhibitions

1961 *Gillian Jagger: Paintings*, Ruth White Gallery, New York, NY, April 18–May 6

1963 *Gillian Jagger: White Light Paintings*, Ruth White Gallery, New York, NY, April

1964 *Reliefs, Molded from Manhole Covers*, Ruth White Gallery, New York, NY, September 22–October 10

1967 *Sculpture: Manhole Covers to Tracks to Tracings*, Ruth White Gallery, New York, NY, October 24–November 14 and University Center, Drew University, Madison, NJ, October 1–November 14

1973 *Environmental Sculpture and Paintings*, Lerner-Heller Gallery, New York, NY

1975 *The Horse, Light and Motion*, Lerner-Heller Gallery, New York, NY, January 7–25

1976 *Impressions*, Lerner-Heller Gallery, New York, NY, December 30, 1975–January 17, 1976

1977 *Gillian Jagger: Africa*, Lerner-Heller Gallery, New York, NY, January 8–29

1979 *Gillian Jagger: Origins and Endings*, Lerner-Heller Gallery, New York, NY, April 28–May 26

1981 *Craggah*, Lerner-Heller Gallery, New York, NY, January 3–January 28

1985 *Cionneamh*, St. Peter's Church at Citicorp, New York, NY, April 30–October 31

1986 *Comhla-Ri* (Together With), The Sculpture Center, New York, NY, February 4–February 25

1987 *Gillian Jagger: Major Works*, Snug Harbor Cultural Center, Newhouse Gallery, Staten Island, NY, October 25–November, 1987

1991 *Lead Works*, Anita Shapolsky Gallery, New York, NY, May 31–July 13

1993 Permanent outdoor installation of the *Gnoman, Sun Piece*, Rockland County Community College, Suffern, NY, September 23

1995 *Recent Works, Gillian Jagger*, The Katonah Museum Sculpture Garden, Katonah, NY, September
Conadus, Trans Hudson Gallery, Jersey City, NJ
Jagger's Environmental Art, Quietude Garden Gallery, East Brunswick, NJ

1997 *Crosscuts*, Trans Hudson Gallery, New York, NY

1998 *Gillian Jagger: New Works: Matrice, The Gathering*, Phyllis Kind Gallery, New York, NY

1999 *Gillian Jagger: Recent Work, Rift*, Phyllis Kind Gallery, New York, NY, March 13–April 24

2001 *Huddle II*, Davis & Hall Gallery, Carriage House Annex, Hudson, NY

2002 *Gillian Jagger: The Absence of Faith*, Phyllis Kind Gallery, New York, NY, May 4–July 29

2002 *The Art of Gillian Jagger*, Elvehjem Museum of Art, University of Wisconsin–Madison, November 23, 2002–January 19, 2003

Group Exhibitions

1956 Loft Gallery, New York, NY

1962 Arts & Crafts Center, Pittsburgh, PA

1965 National Arts Club, New York, NY
Long Island University, New York, NY
Paintings, Jason Gallery, New York, NY

1967 Group show, Ruth White Gallery, New York, NY

1970 C. W. Post College Museum, Brookville, NY
Ruth White Gallery, New York, NY

1971 National Arts Club, New York, NY
Faculty Show, Pratt Institute, Brooklyn, NY

1972 Sculpture Show, Pratt Institute, Brooklyn, NY

1974 Lerner-Heller Gallery, New York, NY

1975 *Woman's Exchange Exhibition*, Pratt Institute
Gallery, Brooklyn, NY, October 2–November 4
Permanent Collection, Finch College Museum,
New York, NY

1976 *Woman Art 1976*, New York University, New York,
NY
Year of the Woman, Reprise, The Bronx Museum
of the Arts, New York, NY
Visual Arts Coalition, Cork Gallery, Avery Fisher
Hall, New York, NY
Alumni Exhibition in New York City, Carnegie
Mellon University, New York, NY

1977 *Paintings*, Ruth White Gallery, Sarasota, FL
Drawings of the '70s, Pratt Institute, Brooklyn, NY
Solidarity with Chilean Democracy, Hamilton
Caymen Gallery, New York, NY

1978 *Art Resources*, Pratt Gallery, The Puck Building,
New York, NY
Currents of '77, Aldrich Museum of
Contemporary Art, Ridgefield, CT

1979 *Faculty Shows Art*, Pratt Institute, Brooklyn, NY
Gates & Fences, Thorpe Intermedia Gallery,
Sparkill, NY

1980 *Current New York*, Joe and Emily Lowe Art Gallery,
Syracuse University, January 27–February 24
The First Ten Years, Lerner-Heller Gallery, New
York, NY, September
Graduate Faculty Art Show, Pratt Institute,
Brooklyn, NY, November 8–24

1982 *Women Artists: Indiana-NewYork Connection*,
Women's Exchange, Six Museums Midwest

1983 *Working with Rocks*, Art Awareness Gallery,
Lexington, NY
Concrete Ideas, Council for the Arts, Kingston, NY

1986 *Eminent Immigrants, Newhouse Gallery*, Snug
Harbor Cultural Center, Staten Island, NY,
June–August

1987 *The Exceptions and the Exceptionals: Women
Artists at Pratt*, Pratt Manhattan Gallery, The Puck
Building, New York, NY, February–March

1990 *4 Sculptors*, Triplex Gallery, Borough of Manhattan
Community College, City University of New York,
New York, NY
Benefit Auction, The Sculpture Center, New York,
NY

1991 *Wood—The Eternal Medium*, Anita Shapolsky
Gallery, New York, NY
Benefit Auction, The Sculpture Center, New York,
NY

1992 *In the Tradition*, Anita Shapolsky Gallery, New
York, NY
Current New York, Joe and Emily Lowe Art Gallery,
Syracuse University, Syracuse, NY
Benefit Auction, The Sculpture Center, New York,
NY
Graduate Art Faculty Show, Pratt Institute of Fine
Arts, Brooklyn, NY
Women of the '60's, Anita Shapolsky Gallery, New
York, NY

1993 *Continuing the Tradition*, Anita Shapolsky Gallery,
New York, NY
Breaking Up Gender Stereotypes, Shirley Fiterman
Gallery, Borough of Manhattan Community
College, City University of New York, New York, NY
The Fine Arts Faculty Show, Schafler Gallery, Pratt
Institute, Brooklyn, NY

1994 *Eight Contemporary Sculptors, Beyond Nature,
Wood into Art,* The Lowe Art Museum, University
of Miami, Miami, FL, April 28–June 12
Bosch's Garden of Delights, Exit Art, New York, NY
Fantasy & Myth, Anita Shapolsky Gallery, New
York, NY

1995 *Presence, Absence*, Trans Hudson Gallery, Jersey City, NJ
The Organic, Green County Council on the Arts, Catskill, NY
Listening to the Earth, Emerson Gallery at Hamilton College, Clinton, NY
Body as Metaphor, The Proctor Art Center at Bard College, Annandale-on-Hudson, NY

1996 *Outdoor Sculpture Show*, Elena Zang Gallery, Woodstock, NY, July 1–October 15
The Body, Anita Shapolsky Gallery, New York, NY, October
Benefit Auction, The Sculpture Center, New York, NY, November

1997 *Aedicules*, Art Omni, Ghent, NY
Leacht, Art in Public Places, Kingston, NY
From the Ground Up, Socrates Sculpture Park, Long Island City, NY

1998 *Pratt Faculty Show*, Schafler Gallery, Pratt Institute, Brooklyn, NY, October

1999 *Pratt Faculty Show*, Schafler Gallery, Pratt Institute, Brooklyn, NY, October

2000 *Symbols of Survival: Images of Animal and Recent Sculpture*, Dorsky Gallery, New York, NY, November 7–December 23

2002 *Auction Show: Silent Auction*, Time Space LTD, Hudson, NY, October 19

BIBLIOGRAPHY

Books

4 Sculptors. Exh. cat. New York: Triplex Gallery, Borough of Manhattan Community College, 1990.

Gear, Josephine. "Thinking in Wood: Contemporary Wood Sculpture in the United States." In Eight Contemporary Sculptors, Beyond Nature, Wood into Art. Exh. cat. Miami, FL: The Lowe Art Museum, University of Miami, 1994.

Gomez, Edward M. The Moment After: Past Postmodernism, Art Finds a New Soul. Articles 8 (September 2002): 154–55 [New York: National Arts Journalism Program at Columbia, 2002]. Electronic book

Lippard, Lucy R. Overlay: Contemporary Art and the Art of Prehistory. New York: Pantheon, 1983, 36, 37, 142.

Perrault, John. Gillian Jagger: Major Works. Exh. cat. Staten Island, NY: Snug Harbor Cultural Center, Newhouse Gallery, 1987.

Journal and Magazine Articles

Adams, Laurie. "Reviews: Gillian Jagger (at Lerner-Heller)," Artnews 72:2 (February 1973): 87.

Brescia, Anna. "Review," Pictures on Exhibit (October 1964).

Brown, Gordon. "Pearlstein, Jagger, Whitman, Gutman," Arts Magazine 42:1 (September–October): 53.

Brown, Gordon. "On the Road to Fame," Art Voices 4:1 (1965).

Brown, Gordon. "Review," Art Voices (September 1961).

Burnside, Madeleine. "Review: Gillian Jagger," Arts Magazine 54:2 (October 1979): 21.

"Faith I," [reproduction] Artforum 40:9 (May 2002): 109.

Florescu, Michael. "Review: Gillian Jagger," Art World 3:9 (May 18–June 19, 1979): 12.

"Forum: Recent Sculptural Developments: Gillian Jagger." Sculpture 14:3 (May–June 1995): 10.

"Gillian Jagger," Pratt Reports 5:4 (winter 1977).

Goodman, Jonathan. "Review: Gillian Jagger at Trans Hudson," Art in America 85:10 (October 1997): 118.

Goodman, Jonathan. "Review: Gillian Jagger: Phyllis Kind," Sculpture 21:10 (December 2002): 72–73.

Hall, Lee. "Gillian Jagger," Arts Magazine 50:10 (June 1979): 18.

I.H.S. "Reviews: Gillian Jagger (White)," Artnews 62:3 (May 1963): 61.

Klein, Michael. "Review: Gillian Jagger: Phyllis Kind," Sculpture 17:8 (October 1998): 55–56.

Koplos, Janet. "Review: Gillian Jagger at Phyllis Kind," Art in America 86:11 (November 1998): 127.

Kuspit, Donald. "Abstraction and Empathy Once Again," Sculpture 21:7 (September 2002): 54.

Kuspit, Donald. "Review: Anita Shapolsky Gallery," Artforum 30:3 (November 1991): 137.

Larson, Kay. "Review," New York Magazine (March 28, 1994).

Liedtke, Walter A. "Art and Nature: The Sculpture of Gillian Jagger," Arts Magazine 55:6 (February 1981): 161–63.

M.B. "Reviews: Gillian Jagger (White)," Artnews 63:5 (September 1964): 62.

"Observing the Arts: Manhattan, '67," Progressive Architecture 49:1 (January 1968): 34.

Nadelman, Cynthia. "New York Reviews: Gillian Jagger/ Phyllis Kind," Artnews 101:8 (September 2002): 153.

Neuman, Elizabeth. "New Sculpture by Gillian Jagger at the Trans Hudson Gallery," New York Soho Arts Magazine (March 1997): 6.

"Pearlstein, Jagger, Whitman, Gutman," Arts Magazine 42:1 (September–October 1967): 53.

Perreault, John. "Gillian Jagger at White Gallery," Artnews 66:6 (October 1967): 13.

R. H. "Reviews: Gillian Jagger (White)," Artnews 60:2 (April 1961): 65.

Review, Look Magazine (September 1964).

"Reviews: Africa," Arts Magazine 51:7 (March 1977): 43.

"Reviews: Gillian Jagger at Lerner-Heller," Arts Magazine 47:6 (February 1973): 89–90.

"Reviews: Gillian Jagger at Lerner-Heller ," Arts Magazine 50:7 (March 1976): 23.

"Reviews: White Light Paintings," Pictures on Exhibit 24:7 (April 1961): 32.

Russell, Beverly. "In the Studio: Gillian Jagger," *Sculpture* 15:3 (March 1996): 8–9.

S. S."Review: In the Tradition, Part II," *Artnews* 91:9 (November 1992): 142.

S.T. "Reviews: Gillian Jagger at White," *Arts Magazine* 35:7 (April 1961): 59.

Smith, Mary. "Dehner/Jagger Address Nature." *Art World* 5:5 (January 16 –February 18, 1981): 1, 10.

"Stones of Many Angels." [reproduction] *Arts Magazine* 53:9 (May 1979): 61.

Strauss, David Levi. "Review," *Artforum* 34:4 (December 1995): 92–93.

Tannenbaum, Judith. "Review: Gillian Jagger," *Arts Magazine* 51:7 (March 1977): 43.

Taplin, Robert. "Gillian Jagger at Phyllis Kind," *Art in America* 90:11 (November 2002): 152.

Newspaper Articles

Barker, Mildred. "Wild at Heart," *Sunday Freeman* [Kingston, NY], September 9, 1990.

Bennett, Carolyn. " Poetry in Stone, Song in Steel," *Woodstock Times*, February 16, 1995.

Brenson, Michael. "Art in Review," *New York Times*, July 12, 1991.

Brenson, Michael. "Review," *New York Times*, February 7, 1986.

Brenson, Michael. "Review," *New York Times*, November 27, 1987.

Brenson, Michael. "What's New Around Town in Outdoor Sculpture," *New York Times*, Weekend, July 19, 1985.

"Buffalo Artist Wins $1,000 Prize," *Buffalo Evening News*, August 24, 1967.

"C-G Community College to Sponsor Lecture by Sculptor Gillian Jagger," *Register-Star* [Hudson, NY], March 30, 2001.

Cacioppo, Nancy. "Rockland's Stonehenge, A Modern Day Megalith Rises at R.C.C.," *Rockland Journal News* [Rockland County, NY], September 17, 1993.

Combs, Tram. "Geological Art Awareness," *Woodstock Times* [Woodstock, NY], June 16, 1983.

Cotter, Holland. "Gillian Jagger— 'The Absence of Faith' [review]," *New York Times*, June 21, 2002, E.2:37.

Cotter, Holland. "Snug Harbor Cultural Center," *New York Times*, August 18, 1995.

D'Agostino, Josie. "Art Ed; Hang on to What We've Got," *The Prattler*, March 11, 1970.

"Discoveries: Artists Rejuvenate Found Materials," *Hudson River Herald* [Hudson, NY], June 6, 2001.

Fite, Linda. "Absence of Faith," *Times Herald-Record*, July 23, 2002.

Fressola, Michael J. "Stone Talks at the Newhouse Gallery," *Staten Island Advance*, November 27, 1987.

Fressola, Michael J. "This Land Is Their Land," *Staten Island Advance*, October 23, 1987.

Glueck, Grace. "Review," *New York Times*, January 10, 1977.

Gomez, Edward M. "A Head, a Leg, a Flank: A New Kind of Monument," *New York Times*, June 21, 2002.

Gomez, Edward M. "They Speak for the Animals, and Through Them," *New York Times*, November 12, 2000, 39, 42.

Gruen, John. "Five Uptown Shows," *Soho Weekly News*, January 23, 1975, 12.

Henry, Amanda. "Jagger's Art, Animal, Vegetable, Visceral," *Wisconsin State Journal* [Madison, WI], December 8, 2002, F1.

Jaeger, William. "When Location is Everything," *Times Union* [Albany, NY], June 3, 2001.

Johnson, Ken. "Gillian Jagger and Charles Sargeant Jagger at Phyllis Kind Gallery [review]," *New York Times*, April 9, 1999, E.2:40.

Kingsley, April. "Sticks and Stones," *Village Voice*, May 28, 1979.

Levin, Kim. "Choices," [Review] *Village Voice*, December 1, 1987.

Levin, Kim. "Gillian Jagger," *Village Voice*, March 17, 1998.

Lowrey, Maxine. "Manhole Covers Make for Holesome Art," *New York World-Telegram*, August 24, 1964.

Lubell, Ellen. "ArtPick," *Soho Weekly News*, May 24, 1979.

Lubell, Ellen. "When a Good Gallery Folds," *Village Voice*, April 1985.

Lynch, Kevin. "Bringing Death to Life," *The Capital Times* [Madison, WI], November 27, 2002, B1, B6.

Mason, John. "A Tale of 2 Artists," *Register-Star* [Hudson Valley, NY], June 17, 2001.

Maxwell, Douglas F. "Gillian Jagger: New Works, Phyllis Kind Gallery," *Review*, March 15, 1998, 17.

McCoy, Mary. "Gillian Jagger," *Woman's Studio Workshop [Newsletter]*, November 27, 1987.

Naves, Mario. "After a Plague of Dead Fauna, A Disquieting Homage to Life," *New York Observer*, July 1–8, 2002.

Naves, Mario. "Currently Hanging," *New York Observer*, July 1–8, 2002.

Perreault, John. "All It's Cracked Up To Be," *Soho Weekly News*, January 21, 1981.

Perreault, John. "Gillian Jagger: Crossing the River," *Review*, February 15, 1997, 5.

Perreault, John. "What Happened in 1981," *Soho Weekly News*, January 12, 1982, 42.

Perreault, John. "The Year In Pictures," *Soho Weekly News*, January 12, 1982.

Preston, Stuart. "Review," *New York Times*, September 26, 1964.

Prutzman, Priscilla. "Kerhonkson Sculptor Wins Guggenheim," *Ellenville News*, August 11, 1983.

Prutzman, Priscilla. "Local Artists Win Grants," *Sunday Freeman* [Kingston, NY], February 15, 1981.

Review. *London Daily Telegraph*, October 4, 1964.

Raynor, Vivien. "Review," *New York Times*, June 4, 1979.

Raynor, Vivien. "A Sculpture Show with Butterflies," *New York Times*, July 28, 1996.

"Review," *Village Voice*, September 15, 1967.

Ruckman, Roger. "Lowe Exhibit Shows Diversity of Relief Art," *Daily Orange* [Syracuse, NY], January 30, 1980.

"Sculptor to Speak at C-GCC," *Wyndham Journal* [Wyndham, NY], March 29, 2001.

"Sculpture Unveiled At RCC," [photo] *Rockland Journal News* [Rockland County, NY], September 23, 1993.

Stockinger, Jacob. "Jagger Show is Best of 02," *The Capital Times: Rhythm* [Madison, WI], December 5, 2002, 22.

Stockinger, Jacob. "Mammoth 'Spiral' Sculpture Inspires Awe, Reflection," *The Capital Times* [Madison, WI], January 11, 2002, D1, D4.

Watson, Simon. "Gillian Jagger: Matrice," *Simon Says*, March 1998.

Weisberg, Pam. "Formations Inspired by Geological Phenomena," *Art Awareness* [Council on the Arts] (summer 1983), 6.

Wilkinson, Jeanne C. "Gillian Jagger, Recent Works," *Review*, March 1, 1998.

Wilkinson, Jeanne C. "Gillian Jagger, Trans-Hudson Gallery," *Review*, February 15, 1997, 21.

Willard, Charlotte. "In the Art Galleries," *New York Post*, September 20, 1964.

Zimmer, William. "Review," *New York Times*, August 27, 1995.

Editor: Patricia Powell, Elvehjem Museum of Art

Designer: Earl J. Madden, University Communications

Photographers:
Andrew Bordwin, essay figures 7, 8
Douglas Kaftan, essay figure 2
Consuelo Mander, essay figure 3. Courtesy Lerner-Heller Gallery
Kim Massie, essay figure 6
Russell Panczenko, cover, frontispiece, pages 7, 8, essay
 figure 9, catalogue number 19c, catalogue number 30b
Nathan Rabin, essay figure 10
Jim Wildeman: catalogue numbers 12, 3, 4, 8a-b, 9, 10,
 11a-b, 12, 13, 14, 15, 16, 17, 20, 21, 23, 30a 30c-31,
 32, 22, page 64, back cover

Printer: Reis Graphics, Butler, WI